THE
BOOK
OF THE
UNICORN

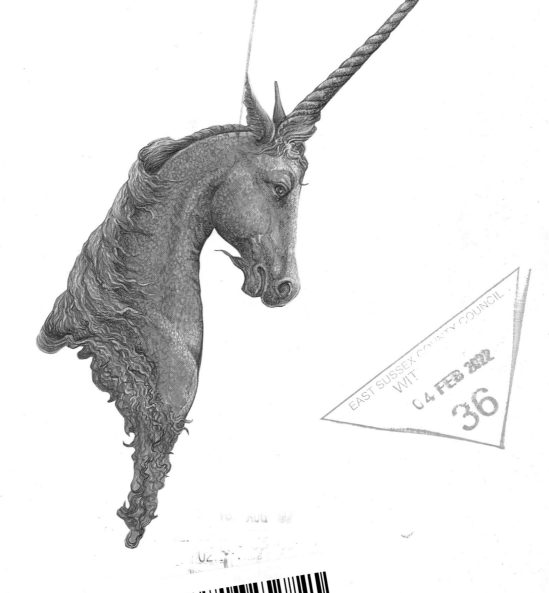

THE
BOOK
OF THE
UNICORN

TEXT BY NIGEL SUCKLING

ILLUSTRATED BY LINDA & ROGER GARLAND

PAPER TIGER

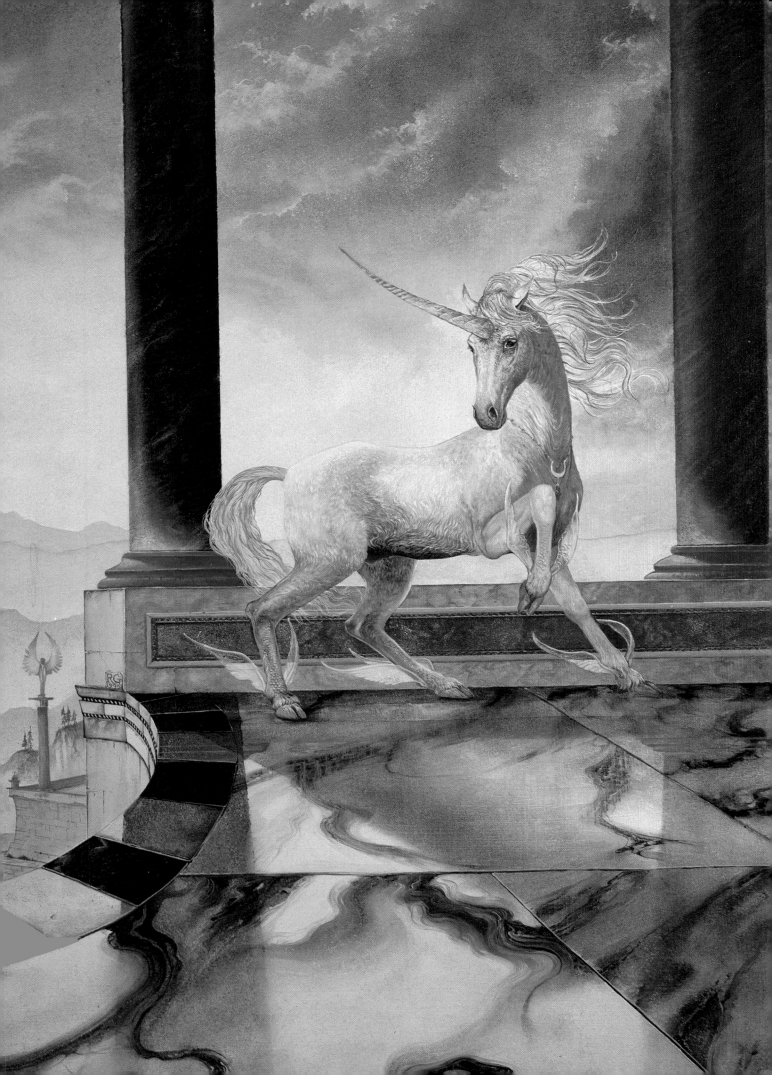

Paper Tiger
An imprint of Dragon's World
Dragon's World Ltd
Limpsfield
Surrey RH8 ODY
Great Britain

First published by Dragon's World Ltd, 1996

Designer: Karen Ferguson
Art Director: John Strange
Editorial Director: Pippa Rubinstein

ISBN 1 85028 360 5 Limpback
ISBN 1 85028 407 5 Hardback

Quality printing and binding by
Kyodo Printing Company Limited, Singapore

(Previous page) *Winged Unicorn*

CONTENTS

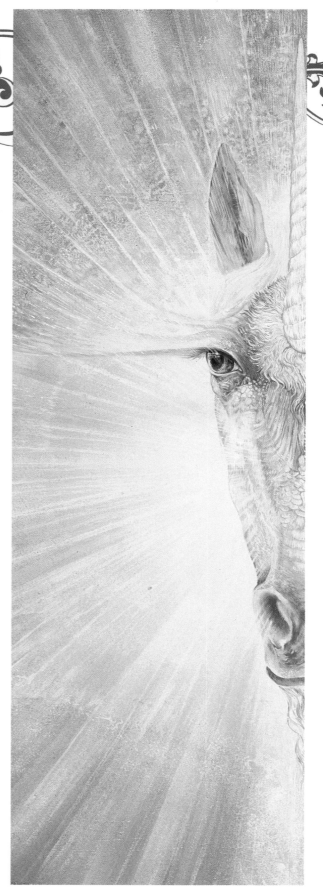

Introduction

Who has not heard of Unicorns? Just contemplate the word and a vivid picture will form in your mind's eye. In the West we conjure up an image of a white, horse-like creature with a mystical aura of calm, gentle wisdom radiating from the single, sharp, spiralling horn on its brow. Shy and elusive, it haunts the margins of our consciousness like the memories of childhood. Focus upon the image and it comes to life with a strange, compelling intensity, inspiring feelings of high chivalry and unselfish ambitions. Wonder, mystery, the promise of adventure and more than a hint of the otherworld all cling to the idea of Unicorns. But where does it all come from? How has the Unicorn managed to live on in the Western imagination?

There is the famous English nursery rhyme and the heraldic Unicorn in the royal coat of arms. Many people have a vague memory of Unicorns in Medieval tapestries and perhaps recall the passing appearance of one in the Grimm's fairytale about the brave little tailor. Beyond that, when you take time to look, you will find the Unicorn is used as a corporate symbol

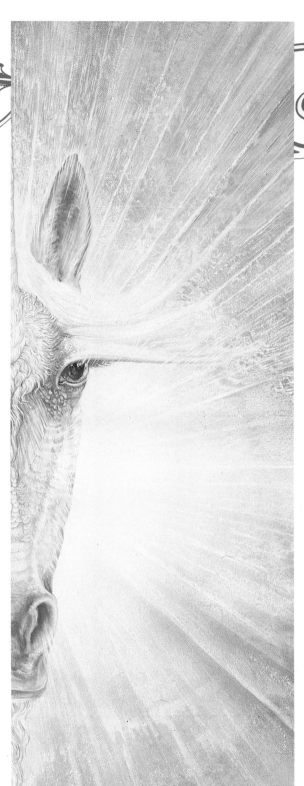

for all kinds of enterprises ranging from publishing to sports equipment. But this is only the re-use of a symbol already in existence. It may reinforce our awareness of Unicorns but does little to enhance our perception of them.

Fantasy art and sculpture often use Unicorns as a theme, along with dragons, wizards, goblins and the like. However, whereas we can usually point quickly to stories that have shaped our feelings about the rest, Unicorns draw a curious blank. One searches almost in vain for the source of our ideas about them. It is almost as if they were somehow imbibed with our mothers' milk. However sure we feel that at some point we must have read or been told what we believe about Unicorns, putting one's finger on the time and place is surprisingly hard.

The plain fact is that there are remarkably few stories about Unicorns around, considering their fame, and few of those are widely known. The presence of the Unicorn in the collective consciousness is a slight mystery, but there are many things one can say about it without much fear of contradiction. A degree of

◀ *Moonlight*

sentimentality has recently crept into the picture, a tendency to forget the fierce side of the Unicorn's character and imagine its form as simply that of a horse with a horn, but these are fairly superficial glosses.

Many varieties of Unicorn have been reported through the ages and from around the world. The most famous kind is probably that which appears in the tapestries of the European Middle Ages, particularly those now on display in the Cluny Museum, Paris, and in the Cloisters Collection of the Metropolitan Museum of Art, New York. These show the milk-white Unicorn looking horse-like at first glance but more delicately built and with distinctly cloven hooves like those of a deer. It has a wispy beard and long, silky mane and tail. The horn stands out straight and tall from the centre of its forehead, impossibly tall really, but this only adds to the charm of the tapestries.

It is said that Unicorns' eyes are deep blue and seem to be full of stars. They are also reputed to be able to converse with humans but in a strange telepathic way that has no need of words. Their audible voice is rarely heard and then only as a cry of rage when driven beyond endurance, a scream so dreadful that often it is enough in itself to destroy the sanity of an aggressor.

Unicorns are not easily provoked but they guard their lives and independence fiercely and would sooner die than submit to the indignity of capture. Usually, though, they are of a placid, gentle disposition and the natural friend of most other creatures – even the lion when it does not encroach upon its territory. The touch of a Unicorn's horn dispels poison, so other beasts let it

drink first from the spring. This is one reason why the Unicorn is often called Lord of the Beasts and why all pure-hearted animals will shield it from its enemies if they can.

Although friendly towards other animals, the Unicorn is solitary by inclination, particularly keeping away from its own kind except after mating, when couples live together in tenderness while rearing their young. Occasionally, however, they do gather in herds or assemblies and it used to be said that once a year they journeyed to the site of the Garden of Eden at the source of the River Euphrates.

The Bible itself is silent on this matter but early Christian legend, echoed in many later paintings, tells how the Unicorn was the first creature to be named by Adam after the Creation, for which reason it was particularly blessed by God with grace and intelligence. First among the four-footed beasts, the Unicorn was as distinct from the rest as Adam and Eve themselves and a special friendship grew up between them in Eden. When the humans were expelled from Paradise, the Unicorn was given the choice of staying but out of compassion chose to follow Adam and Eve into the harsh world. For this reason Unicorns have always had a natural affinity with humans, females in particular, and curiosity about their affairs. However, this is tempered by extreme caution since most of Adam's descendants have only ever been interested in hunting the Unicorn's horn.

This greed rose to a peak in Europe during the Middle Ages when, perversely, the Unicorn was also at its height of popularity. It was highly venerated as an

emblem of Christian and chivalric virtue. Hunting the Unicorn for the sake of its horn is the theme of innumerable Medieval tales, far less common are tales of peaceful intent. As with the rhinoceros today, the horn was generally prized more than the whole beast running around in the wild. As we shall see, this is not totally surprising however sadly it reflects on human nature.

The problem for hunters, though, was how to catch the beast. It was too wise to be trapped by any usual means and too fierce to be overcome even if it could be cornered. Sadly for the Unicorn a way became widely known, thanks to the popularity of a book called *Physiologus Graecus*, a widely-known Medieval bestiary. It revealed the secret of the Unicorn's blind spot and described how to catch the creature in verses like this one from sixteenth-century Germany:

> *The wise man says these animals*
> *Lust greatly after pretty girls.*
> *This way to catch them is the best,*
> *A youth in women's clothes is dressed*
> *And then with dainty steps he flaunts*
> *About the Unicorn's bright haunts.*
> *For when this creature spies a maid*
> *Straight in her lap he lays his head.*
> *The huntsman, doffing his disguise*
> *Saws off the horn and wins the prize.*

Whether the Unicorn was ever quite this gullible is open to question, but even the wisest of creatures have their blind spots. Another variation on this theme involves persuading or tricking a maiden to act as bait for the hunter's trap. If only half the surviving tales of the success of these methods are to be believed, it is hardly surprising that Unicorns became increasingly rare after the Middle Ages.

The ploy was not without danger for the bait, however, and some authorities warn that if the Unicorn saw through the deception it was liable to despatch a deceiver to Heaven before making its escape.

The Unicorn's trust in maidens is thought by some to be due to its association, in pagan times and lands, with cults of the moon and the virgin priestesses who administered to them. With the coming of Christianity, this bond was extended to nuns who, with some notable exceptions, guarded the Unicorn's faith as well as their predecessors.

The art of using maidens to catch Unicorns was once common knowledge in Ethiopia, the Near East and India, from whence it probably filtered through to Europe. In China the method was unknown or perhaps simply ignored because the idea of deliberately trying to kill Unicorns seems not to have entered the Chinese mind. This is surprising, considering the wide use of animal products as medicines there. Even today, dragons' teeth are still to be found on sale in some traditional Chinese pharmacies.

Descriptions of the Unicorn vary slightly throughout these lands. Yet more surprising than the differences are the similarities, given that elusiveness has always been one of the Unicorn's main attributes. Assessed globally, Unicorns have not achieved the same fame throughout the world that they have enjoyed in the West, but their ability to fascinate does seem almost universal and wherever they have made their presence felt, they strike the same chord in the human heart.

CHAPTER 1

The

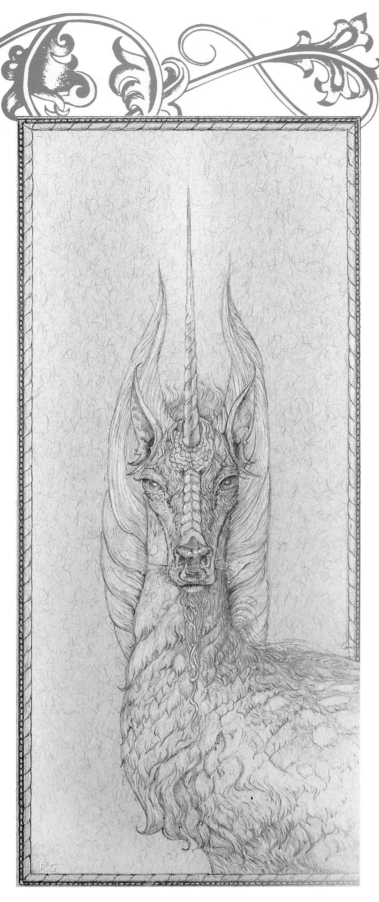

nicorns are almost as elusive in storytelling as they are in the real world. Rumours abound but rarely are we given more than a fleeting glimpse of these marvellous creatures. In the places we might most expect to find them, such as the sprawling Arthurian romances, they are almost totally absent. Other far more obviously fantastic creatures abound – dragons, griffins, giants; the magical White Hart and mysterious Questing Beast – but almost no Unicorns.

Apart from the legends about Alexander the Great, the Unicorn is also rare in the other great Medieval story cycles, such as those centered on Charlemagne and Roland. It seems almost a conspiracy of silence, but one could argue that it follows from the nature of the beast. Unicorns are famously solitary, contemplative creatures that avoid conflict. Action, particularly violent action, is not their natural mode.

Legends

They are perfectly capable of it, terrifyingly so at times, but only as a last resort.

The Unicorn's nature is like that of the archetypal Eastern mystic lost in solitary contemplation on the Himalayan heights. Or the forest-dwelling hermits so common in Arthurian tales. Like them it shuns the hurly burly of the world and seeks the quietest places as far as possible from the habitations of man.

Luckily there are exceptions, and we open this investigation with a few tales which, in their own way, say as much about Unicorns as the lore which follows; tales written or recited in days when no-one doubted their reality any more than that of lions, camels, hippopotami or any other such creature they had not actually seen with their own eyes.

The Indian tale may seem a little out of place, telling as it does of a human Unicorn, but it fits with the rest as a refinement of the legend. If a Unicorn were to adopt human form, this is how it might be tempted to further embroil itself in human affairs, with all the consequences related in the story.

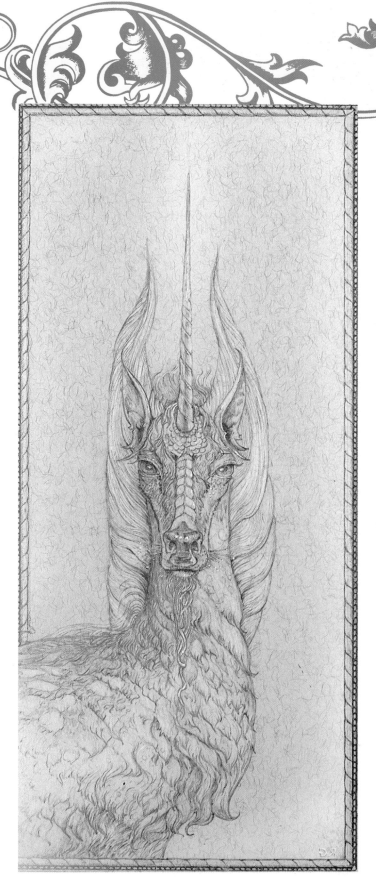

The Unicorn & the Maiden

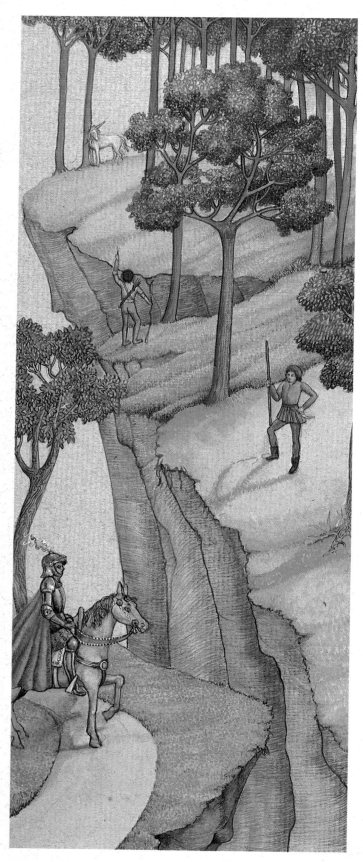

Long ago, on the edge of the forest of Broceliande, there lived a King called Boron who was hated by his people. He was also hated by the people of all the neighbouring kingdoms because he was constantly at war with them. He was a sour man who trusted no one and always suspected plots against his life. This wasn't an unfounded fear because the more bellicose he became, the more his people longed to be rid of him.

Boron had not always been a bad man, but disappointment and grief had poisoned his soul. In his youth he had been known as Boron the Blessed but now he had come to be called Boron the Bitter. The only soft spot remaining in his heart, it seemed, was for his daughter Therese. This was not just the special bond between father and daughter; she inspired love in everyone. She was one of those people who can only see the good in others and, in fact, many of her father's excesses were forgiven for her sake.

It happened one day that a Unicorn was seen in the forest near Boron's kingdom. As news of this spread from huntsman and forester to peasant and burgher many people recalled the circumstances when a Unicorn last appeared. It had coincided

A Unicorn was seen in the forest ▲
Therese and the Unicorn ▶

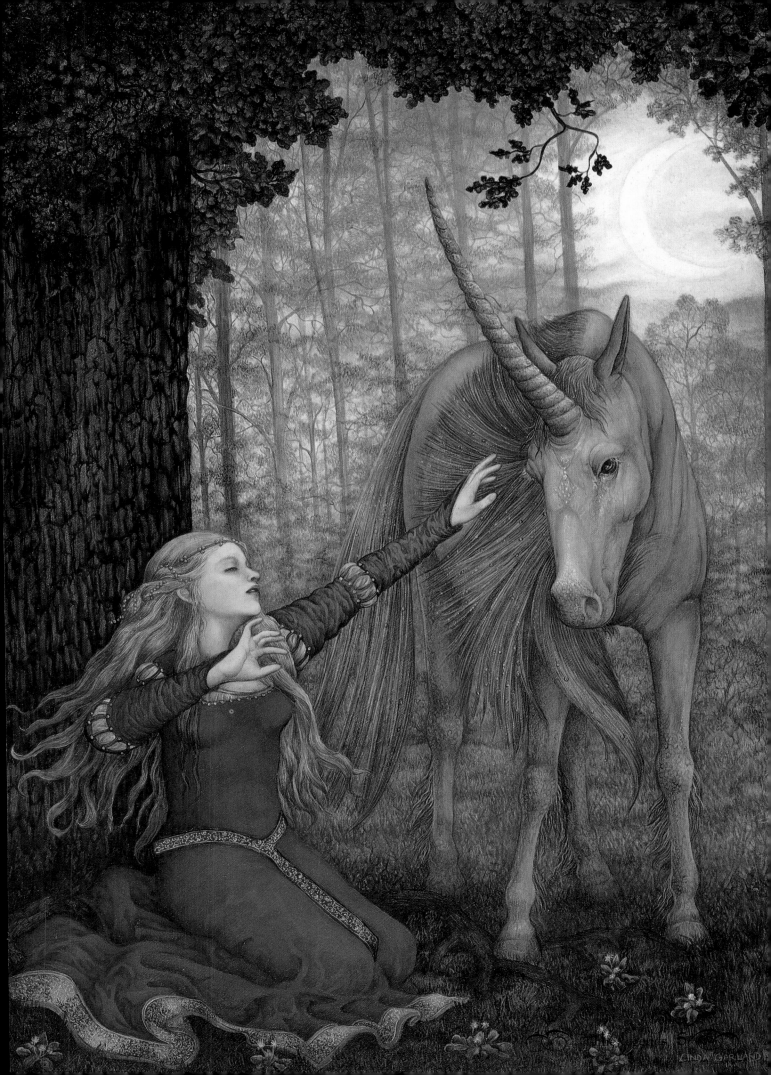

with the death of Boron's grandfather –
whom he was rapidly coming to resemble –
and was believed to signify the end of an
evil reign. This inspired a mood of hope in
the people and smiles were seen on faces
that had not known joy for many years.

The King was the last to hear the news
of the Unicorn. Oblivious to the
significance of the Unicorn's presence, he
thought only of acquiring the beast's
precious horn. So he gathered all his wisest
advisors together to plan how the desired
object could be taken.

'It cannot be accomplished by force',
they told him. 'Neither the stealthiest of
hunters nor the bravest pack of hounds can
catch the Unicorn. It is the wisest and
strongest of beasts and in either forest or
mountain it can disappear like the mist. It
only comes within reach of humans it
trusts and they are none but the purest
maidens.'

'Then find me a pure maiden and we
will set a trap with her,' said the King
impatiently.

'But if she knows of the plan, my lord,'
they replied, 'the Unicorn may sense it and
keep away.'

'Then we won't tell her, you fools,'
Boron roared, 'and if any of you breathe a
word of this without my leave, your heads
will go to feed the crows on the gatehouse.'

Boron was not a completely bad man so
when it was pointed out to him that the
purest maiden in all the kingdom was
undoubtedly his own daughter, even he
had qualms. He could perhaps have chosen
some other maid but this seemed an insult

to his daughter's honour, besides lowering
the chances of success. So in the end, after
wrestling with a conscience well used to
defeat, he decided to go ahead and use
poor Therese as unwitting bait for his
Unicorn trap.

The next day Boron and his daughter set
off on horseback, accompanied by a dozen
of his truest knights. The King told
Therese he wished only to watch the
Unicorn from a distance, should it choose
to approach her.

'Surely we do not require so much
company to meet the peaceful Unicorn?'
the princess asked her father.

'Of course not, my dear, but the world is
full of our enemies so bear with them for
my sake. Besides, they too would like a
glimpse of this marvel.'

As they neared the forest they met a
pleasant young Knight riding towards them
bearing a shield of pure white. The King
asked if he had any tidings of the Unicorn.

'I have been seeking the creature all
night in vain,' the Knight replied, 'and
many other nights and days past. There is
nothing in all the world I wish to find more
than the holy Unicorn.'

'You mean it no harm, do you?' asked
the princess.

'I would stake my life against any who
wish harm to the creature, my lady, and
have done so many times in this quest.'

'Then you must come with us,' she
declared, 'for we too seek the Unicorn
in peace.'

To the King's private rage the Knight
accepted and in due course the party came

to a clearing in the forest. A mighty oak grew in the centre and a steep mountain overlooked it. The princess settled herself to wait on silken cushions amid the roots of the oak while the King and his knights withdrew to the forest. There they overpowered the Knight and left him tied to a tree before dispersing to lay their trap.

All that day Princess Therese waited with no sight of the creature. Then as the sun set and the full moon rose, and both planets ruled the sky jointly for a while, she caught a faint glimpse of the Unicorn. It stood in the shadows beneath the nearest trees, as pale and insubstantial as a ghost.

For a long time the Unicorn watched Therese in still silence and she too dared not stir for fear of frightening it away. Then with the cautious grace of a deer it stepped into the open and trotted towards her, its snow-white mane tossing like waves, its slender, spiralled horn flashing against the sky. Therese could scarcely breathe for wonder and when the Unicorn's deep, wise eyes looked into hers she was filled with love and awe for the creature. She felt herself drifting on the edge of a swoon and thought she could hear strains of heavenly music in the far distance.

The Unicorn hesitated until it was sure of the purity of her heart then the holy creature knelt and laid its head in her lap. As she cradled it, the princess was filled with immeasurable bliss. Her tears of joy fell on

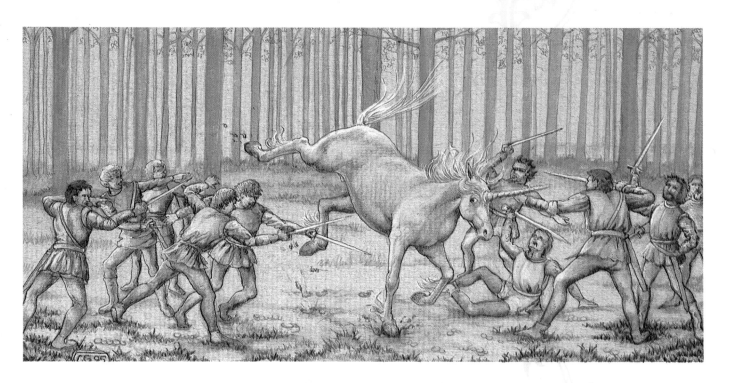

Hunting the Unicorn ▲

to the Unicorn and sparkled like diamonds in the moonlight.

Suddenly, with a roar, a thundering of hooves and a clash of weapons, the King and his knights burst from the trees. The Unicorn sprang to its feet, but already it was too late. The creature was surrounded and as it desperately sought a way through the ring of steel, it let out a pitiful scream of terror. Finally, it was laid low by the crushing blow of a mace and Boron leapt down to strike off its horn.

Therese finally came to her senses and realized what was happening. With a cry she ran across the clearing between the flashing hooves of the circling horses and threw herself on the fallen Unicorn and cradled its head in her white arms.

'Kill me first,' she cried, 'for I cannot live knowing I have betrayed so noble a trust.' Boron was furious. 'Pull her away,' he screamed at his men. But none of them dared lay a hand on the princess, so great was the love she inspired.

The King was enraged. He tried to pull her away himself and when that failed he very nearly struck at the horn anyway, not caring if he hit her. But in mid-stroke he realized what he was doing. With a flash of insight the King suddenly saw what he had become. He realized he was on the verge of destroying the one person in the world he

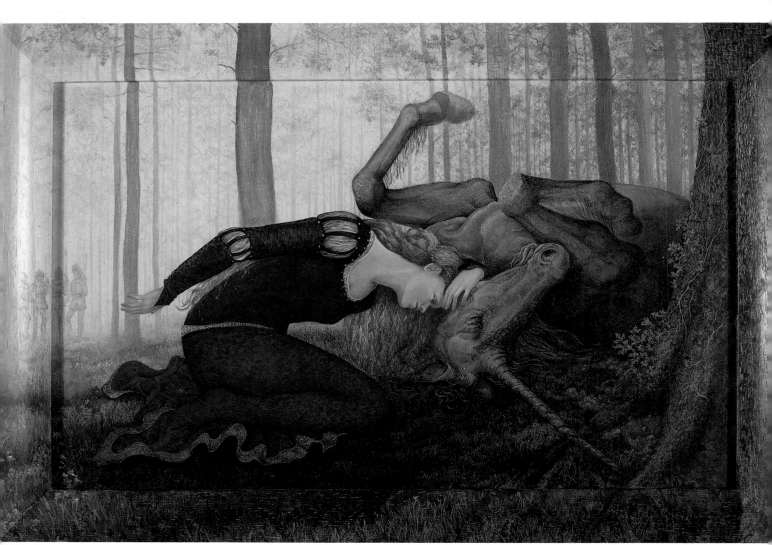

'Kill me first,' she cried ▲

cared more about than himself. Boron threw his sword to the ground and sank to his knees; sobs of shame and remorse wracked his body.

At that point, the Unicorn awoke and with trembling legs struggled to his feet. Boron's knights withdrew and huddled under the trees, for they too were now ashamed of what they had tried to do. The Unicorn rose and let the maid soothe him awhile, then it turned to face the King. The creature moved towards Boron and lowered its horn until its point touched his neck. The repentant King neither flinched nor tried to defend himself.

'Please,' begged Therese, 'for my sake, spare my father.'

The Unicorn turned towards the princess with an enigmatic look in his eyes and then, with a few swift bounds, was gone like a flash of silver under the moon.

From that night forward Boron was a changed man. Or rather, he reverted to being the man he used to be, open-handed and honest and no more suspicious of others' intentions than the ways of the world demand.

So, just as the people had thought, the Unicorn's coming did indeed presage the end of an evil reign. However, on this occasion the King did not die. He was simply transformed into the good and honest ruler the people wanted.

The next time the Unicorn showed itself in his country it was to signal Boron's death, or perhaps to lead him from this life to the next. But this time love of the Unicorn in that place by the forest of Broceliande was matched only by sorrow at the king's passing.

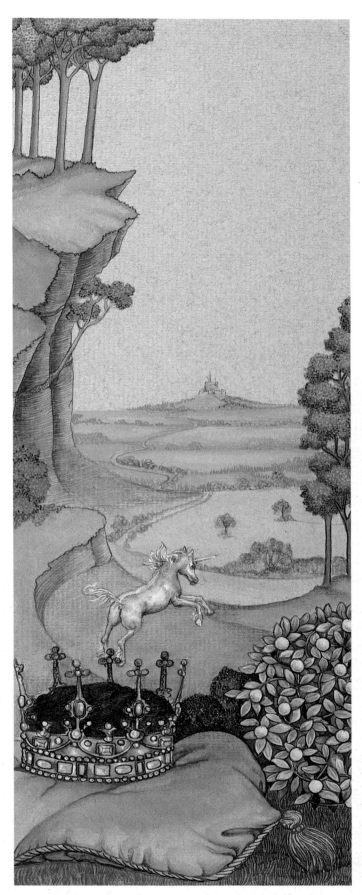

▲ *End and beginning of a reign*

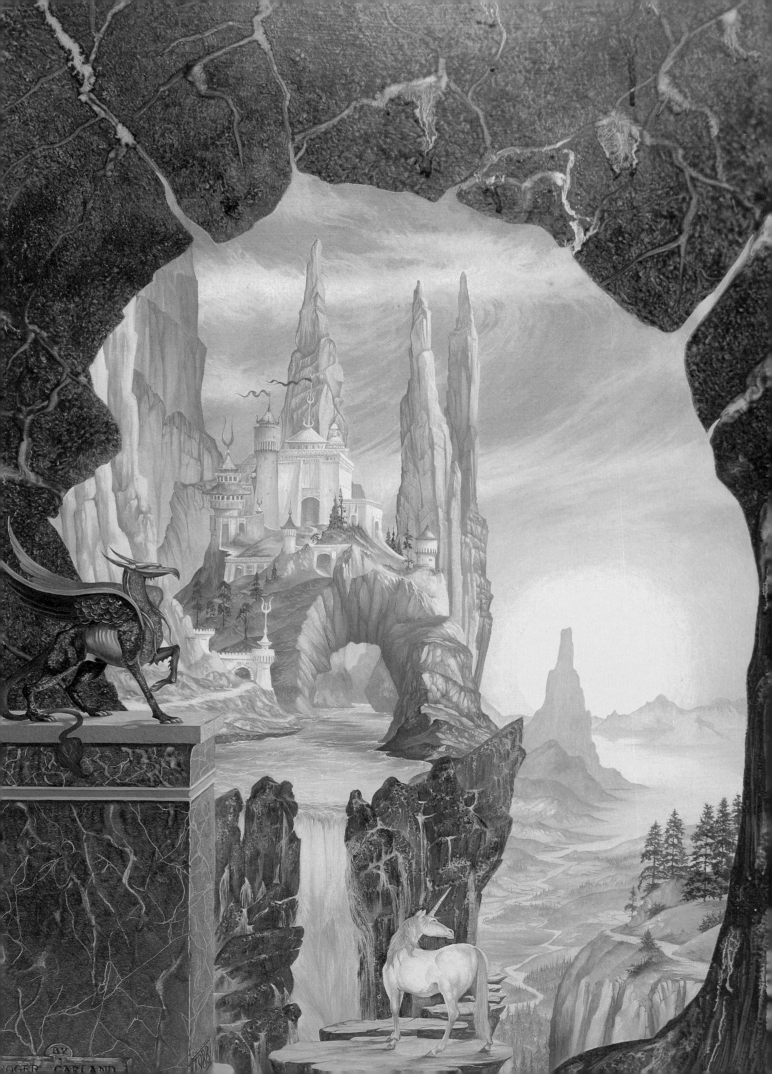

The Knight of the Lion

In the high Middle Ages the king of Friesland had a daughter who was so beautiful and kind, so chaste and gentle, that heaven sent a Unicorn to be her constant companion in the gardens of the palace. For this reason she became known as The White Lady, Ward of the Unicorn.

In time she married a brave knight of good lineage and grand estates, and when she moved to his castle the Unicorn went too and continued to be her faithful companion.

Soon the White Lady was as beloved in her new home as she had been in the old and, as was the custom of the time, many young knights sought to become her champion and wear her emblem in battle. They were the sons of kings, dukes and barons, but out of them all her heart settled on one of the most humble. She chose Bartholomew as her knight and champion and she gave him her scarf to wear as a mascot.

With a glad heart Bartholomew rode out into the world and, although he had been a bold enough knight before, he now felt invincible. Everywhere he went he overcame evil and at every tournament he was acclaimed the champion. With each

triumph Bartholomew proclaimed loudly in whose name he acted and the fame of the White Lady spread far and wide.

Whilst on his travels Bartholomew woke one night in terror to find himself under attack from a lion in whose cave he had unwittingly chosen to sleep. He defended himself and a fierce struggle followed. They were well matched and their contest continued until dawn. At first light they stopped fighting and drew apart, both of them exhausted and injured. They rested for a long time and as the knight watched the lion he found himself admiring the creature more than he feared it. Then the lion did a surprising thing: he lay down defencelessly at Bartholomew's feet and held out a paw in friendship.

From that day on the knight and the lion were never parted. Bartholomew became known as the Knight of the Lion and his fame and that of his lady spread even further.

From time to time in his travels the Knight of the Lion visited the White Lady to tell of his adventures. A great love grew up between them, but it was also a chaste love that gave her husband no cause for jealousy. The Unicorn still sat by her in the garden and condoned their love.

One day when Bartholomew arrived at her castle he was stopped at the gate by a squire in black livery with a golden lion embroidered on the tunic. 'Sir, you cannot enter,' he said, 'this place is in mourning.'

'In mourning, for whom?' the knight asked, surprised because no one of note had been ailing on his last visit.

◄ *The Knight of the Lion*

(next page) *End of the Battle*

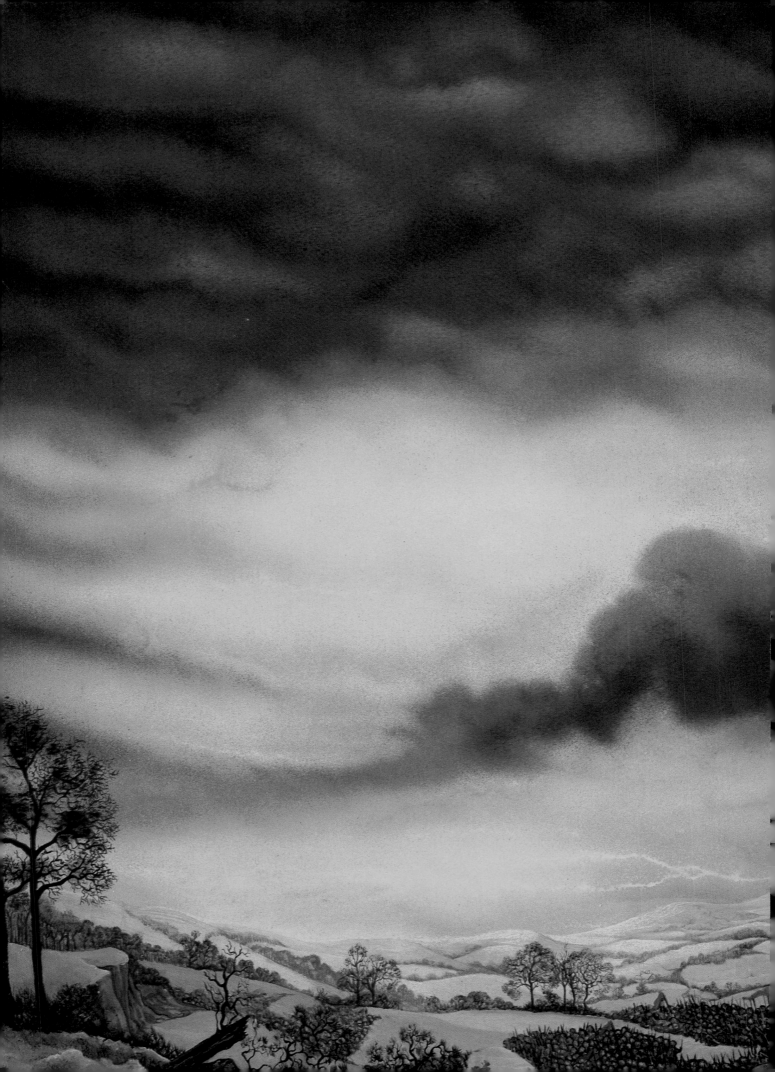

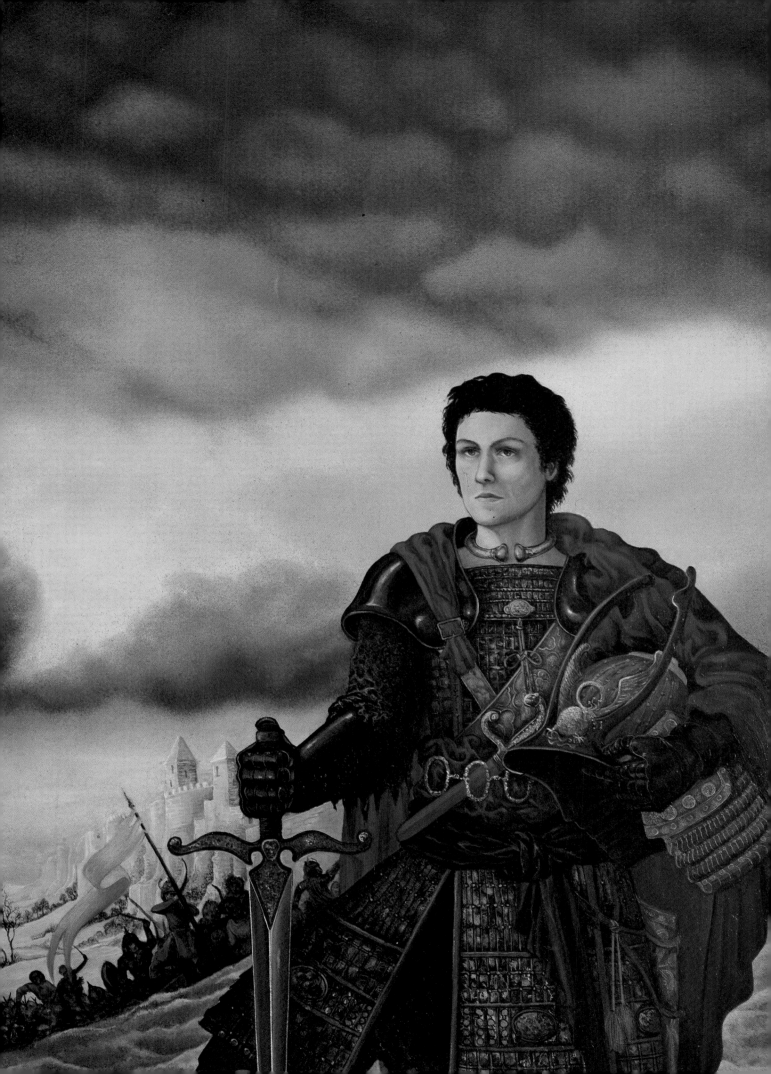

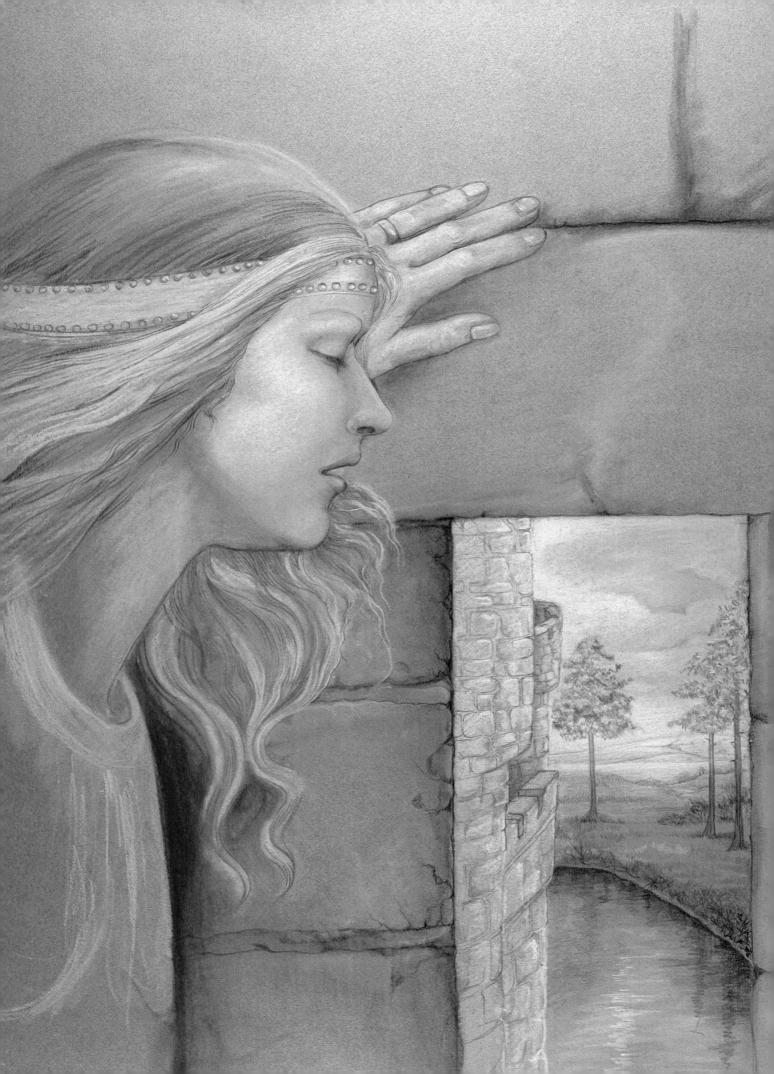

'Why, the White Lady, sir. She passed away just yesterday. A sudden illness. No one within can speak for grief.'

The knight's world seemed to fall apart there on the drawbridge and all that he had accomplished in his lady's name suddenly tasted like ashes in his mouth. In a fit of rage and grief he cast his weapons and armour into the moat and ran off wildly into the nearby forest. There, for a while, his grief turned to madness and he stumbled about aimlessly like a blind and savage beast.

Back at the castle the messenger in black left the gate and sought out the White Lady, whose health and spirits had never been better, save perhaps for a certain longing to see her champion again.

'Lady,' he said, 'I have news for you of the Knight of the Lion.'

Seeing the emblem on his tunic, she believed this. 'What news?' she asked.

'Lady, he is dead,' said the messenger. 'Just yesterday, in the woods nearby, he was killed on his way to visit you, set upon by twelve outlaws. Both he and his beast were slain and their heads taken as trophies.' The White Lady fainted with grief.

This man in black was a rogue knight who had long coveted the White Lady from afar and while she was unconscious he tied her up and bundled her into a sack. Slipping from the castle, he bore her away on horseback to his castle. It was securely positioned high in the mountains with a precipitous drop on three sides whilst the fourth side was protected by a dragon. Once there the White Lady was locked in a

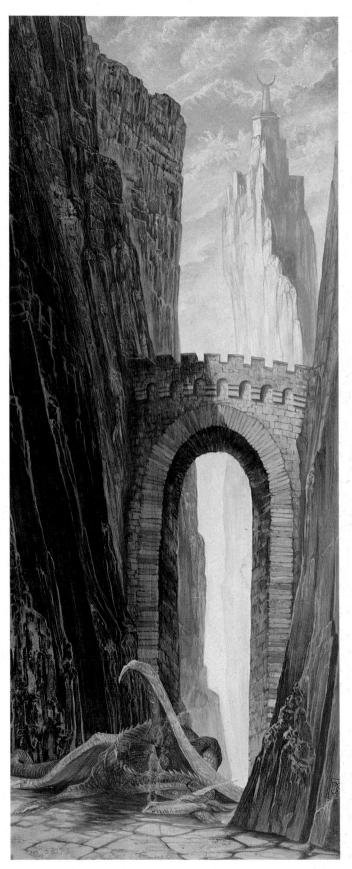

◀ *In search of the maiden*　　　▲ *Guardian of the gate*

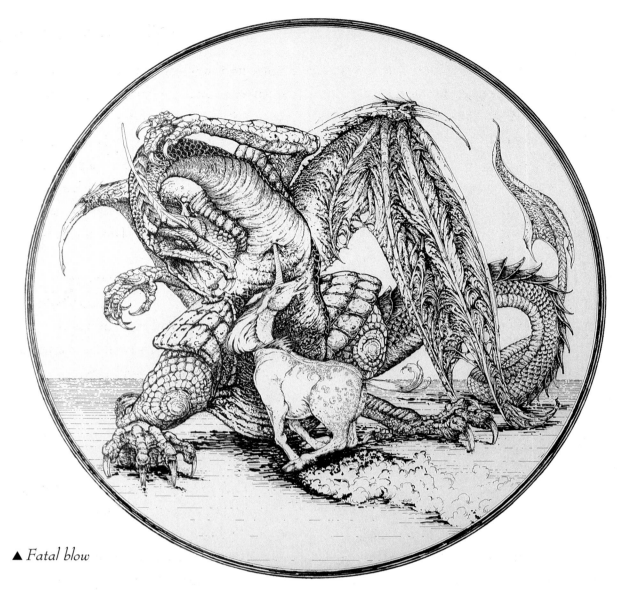

▲ *Fatal blow*

tower and the rogue knight threatened not to release her until she agreed to become his bride. Imprisoned in the tower, she was separated from all that gave her life meaning and fell into a desperate state.

Meanwhile, the Knight of the Lion was rescued from his madness by his faithful lion who guarded and protected him from the worst excesses of his torment until a degree of sanity returned.

Whilst recovering, the knight heard from a passing stranger that his lady was still alive and all his former strength and confidence returned to him. Riding on the lion's back, he went straight to the White

Lady's castle to pledge himself to her rescue. There he found her husband and his knights recovering from an heroic attempt to storm the rogue knight's castle. They had been heavily defeated and were nursing the dreadful wounds inflicted by the fearsome dragon. They were ill prepared to stage a second attack on the castle so, after rearming himself, the Knight of the Lion went into the mountains with his beast.

The rogue knight's dark castle, although not large, seemed impregnable as the Knight of the Lion approached it. But before he could even attempt to enter the

castle he had to slay the dragon which was lying seemingly asleep at the castle gate. The knight fitted his lance to its rest, raised his shield and charged.

Dragons can rarely be trusted to be asleep when they seem to be and this one was no exception. Lazily, it raised its golden eyes, opened its jaws as if to yawn and met the charge with a blast of flame. The ferocious heat not only nearly roasted the knight in his armour but knocked him and the lion head over heels back down the rocky track and almost off the edge of the mountain. Gamely they picked themselves up, reeking of burned flesh and fur, and charged again, only to be knocked back as before. They tried a third time but still could not get near enough to the dragon to use the lance.

As the knight and his lion picked themselves up for a third time they knew they had met their match, but pride forbade them from turning back in defeat. As they retired to lick their wounds they suddenly heard a movement on the path below. Up through the acrid smoke now wreathing the scorched mountain, and shining like the moon amidst the murk, came the lady's Unicorn.

There was a wild light in its eyes as it passed and the knight and lion drew back in silence to let it go. Up the blackened, rocky path it went until it confronted the dragon, then the Unicorn reared up defiantly on its hind legs and uttered an awful cry. The dragon replied with a fiery roar and the Unicorn glowed first red then pink amid the torrent. The Unicorn was

neither knocked from its feet nor burned to a crisp and when the flames died down it lowered its horn and charged.

The dragon reared up in alarm and tried to spread its great wings, but they crashed into the gatehouse above. So the ferocious beast attacked, lashing out with taloned forearms, its flaming jaws poised to crush the snowy, graceful neck.

Sparks flashed from the Unicorn's feet and it took to the air like a thunderbolt, streaking past the slashing claws and vicious fangs to drive its horn almost to the hilt into the dragon's angry heart.

The dragon fell dead into the moat, almost crushing the Unicorn as it did. Then the knight rode up and beheaded it before all three victors entered the castle together. The Unicorn's horn was steaming a dark vapour as it cleansed itself of the dragon's blood.

Everyone in the castle fled before them and when the rogue knight realized his defences had been breached, and he was powerless against these assailants, he dropped dead with rage.

So the White Lady was set free and rode home on her beloved Unicorn with her knight and his lion by her side. There were great celebrations on her arrival and her husband was overjoyed to see her. The knight and his lion were hailed as heroes and handsomely rewarded before setting off again on their travels.

(next page) Unicorn triumphant

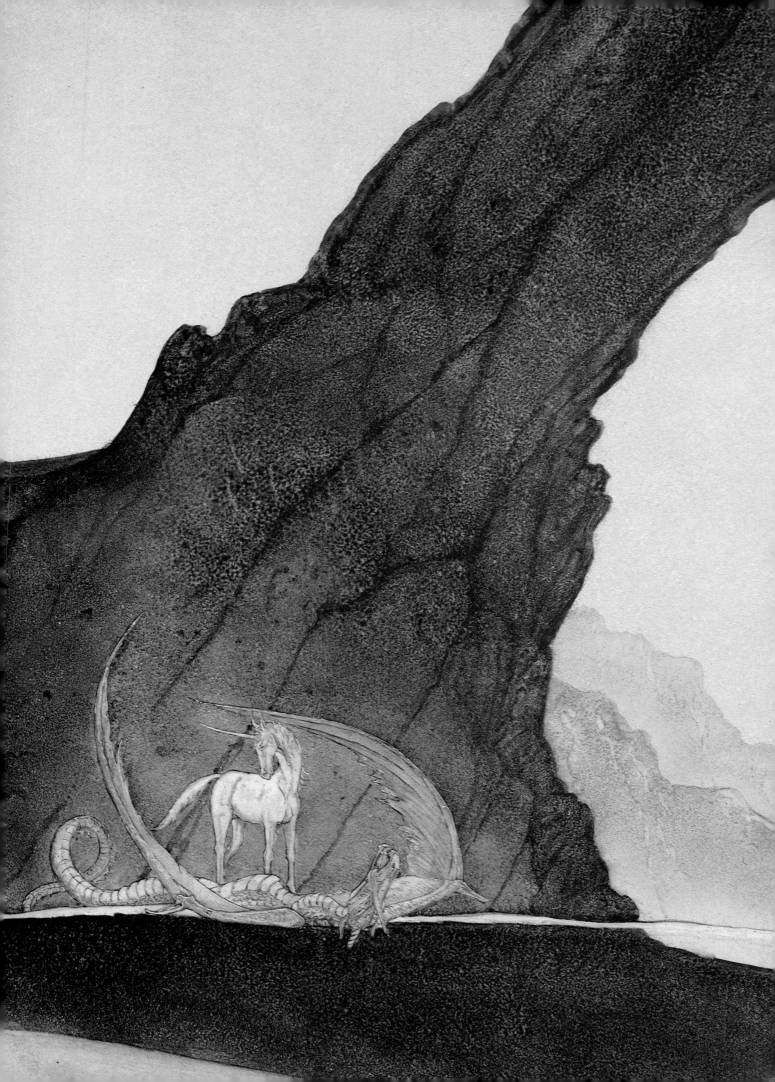

King Arthur & the Unicorn

n his youth King Arthur once went sailing alone in search of adventure. He was overtaken by a storm which blew him far off course, and he ended up stranded on a lonely shore with his vessel stuck fast on a sandbank. Gazing along the rugged coastline, the only sign of habitation was a single, square, red tower at the edge of a forest. So Arthur headed that way to seek help.

It was a strange tower with no doors or windows and, at first, there was no response to his calls. Then a man's head appeared on the battlements. 'Who are you and what do you want?' he called down, gruffly. Arthur explained how he needed help to free his ship from the sands.

The stranger appeared to soften a little. 'It is a reasonable enough request,' he replied, 'but nothing can be done until my son returns from hunting. If you are prepared to wait, we will surely help to set you on your way.'

Since he had little choice, and was by

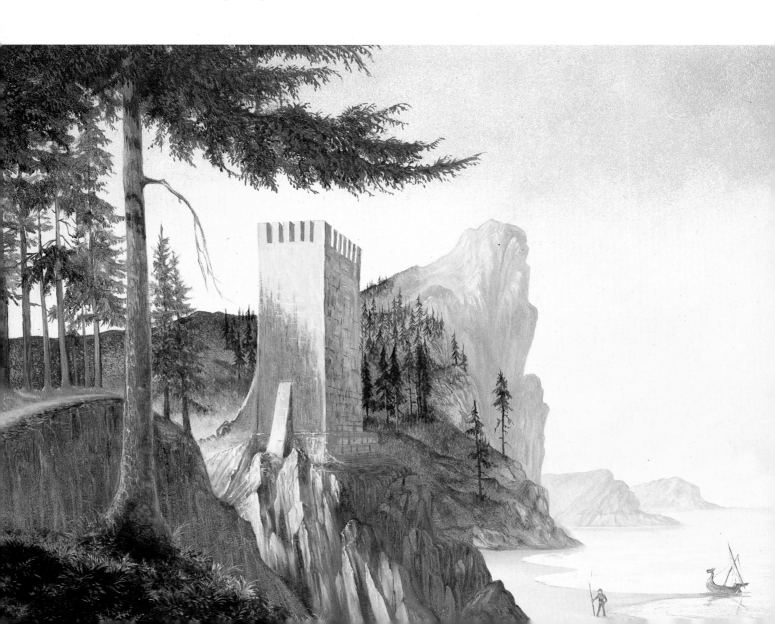

now curious about the man in the tower, Arthur settled down to wait. In due course he asked the stranger how he came to be living in such a remote place.

'Sir,' came the reply from the battlement, 'you cannot tell this from where you are, but I am a dwarf and long ago I was in the service of the ruler of Northumbria. As you must know, a dwarf's life is a precarious one, and when things go wrong we are more likely than other men to catch the blame. So it happened with me, and my master had me banished and set ashore with my wife in this desolate place.

'She, poor lady, died almost immediately in childbirth. After I had buried her, I wrapped the babe in her cloak and went looking for somewhere to shelter for the night from the elements and the wild beasts, for it was winter then and I feared for the child's life.

'In the forest not far from here I found a large hollow tree filled with dead leaves. As I began to make a bed for my child among the dead leaves, I heard a rustling and found a nest of fawns. They had been so well covered in leaves that I didn't see them until they moved. Each fawn had a tiny horn in the middle of its brow.

'Well, I was so taken by this sight that for a while I did not know what to do. Then suddenly the mother returned. She was a great white beast, as large as any horse, with a horn like a lance on her brow. She had a spark in her eyes that said she believed I had been about to steal or harm her children. I panicked and ran and was just about to congratulate myself on my

escape when I realized that somehow I had lost my own son. Then I heard his crying from far away and knew I must have left him back at the hollow tree.

'In fear and trembling I crept back and my heart almost stopped when the babe's crying suddenly ceased. I loved the child greatly both for his own sake and because he was all I had to remind me of my dear wife. As I crept nearer, I found the Unicorn lying in the hollow of the tree with her fawns nursing at her breast, and my own babe in there among them feeding as mightily as if he were their brother.

'That night I hid nearby, almost freezing to death, unable to decide what to do. It was plain that the Unicorn could feed the babe better than I, but how could I abandon him to the care of a wild beast? In the morning the Unicorn left to feed and I took my son and washed him and wrapped him in swaddling as best I could. I intended to return him to the nest, but before I was done, the beast returned. This time, though, she greeted me in the sweetest and gentlest way, and when she lay down with her fawns she motioned with her head for me to return the child to her.

'From that day until he was weaned the Unicorn remained my son's nurse. I built a hut by the hollow tree and we lived together as a family, no evil creature daring to threaten us. Such was the goodness of the Unicorn's milk that my son grew into a giant, soon able to uproot trees with his bare hands. In time he built this tower so I should be safe when he was off hunting or

◀ *Red Tower*

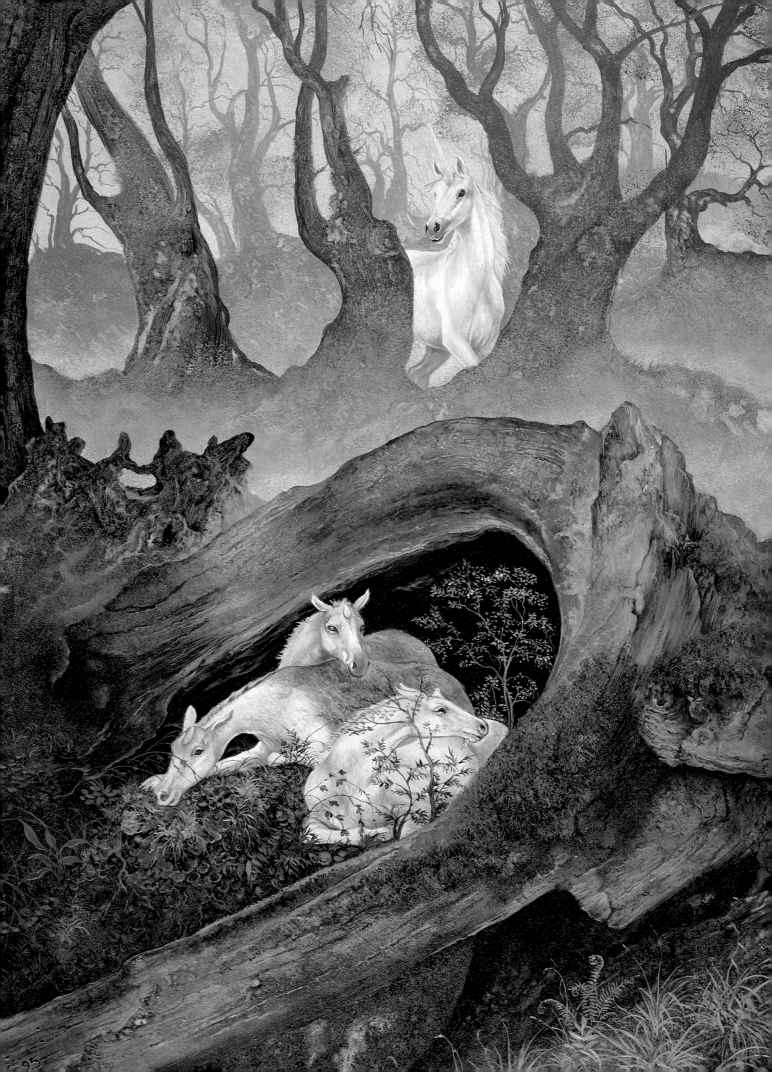

at play. The Unicorn is still my son's constant companion even though her other children have gone off into the world.'

As the dwarf concluded his tale the ground began to shake. 'Here comes the boy now,' said the dwarf, and Arthur, who had not known how much of the tale to believe, was mightily impressed to see a true giant come striding out of the forest with a dead bear slung easily over one shoulder and a mighty club over the other. Beside him came, trotting, a milk-white Unicorn.

The mystery of the tower's absence of doors and windows was explained when the giant lifted Arthur up to the battlements, where he joined the dwarf for a feast whilst the giant remained outside. The following day the giant and the Unicorn helped drag Arthur's boat off the sands and he set sail for home.

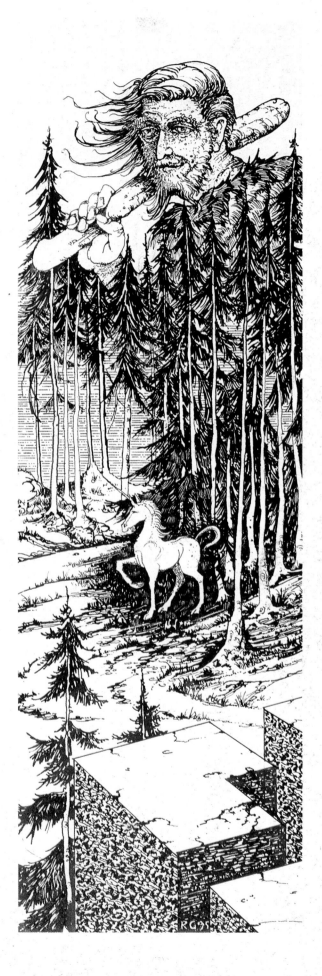

◀ *Nest of fawns*
▶ *Striding out of the forest*

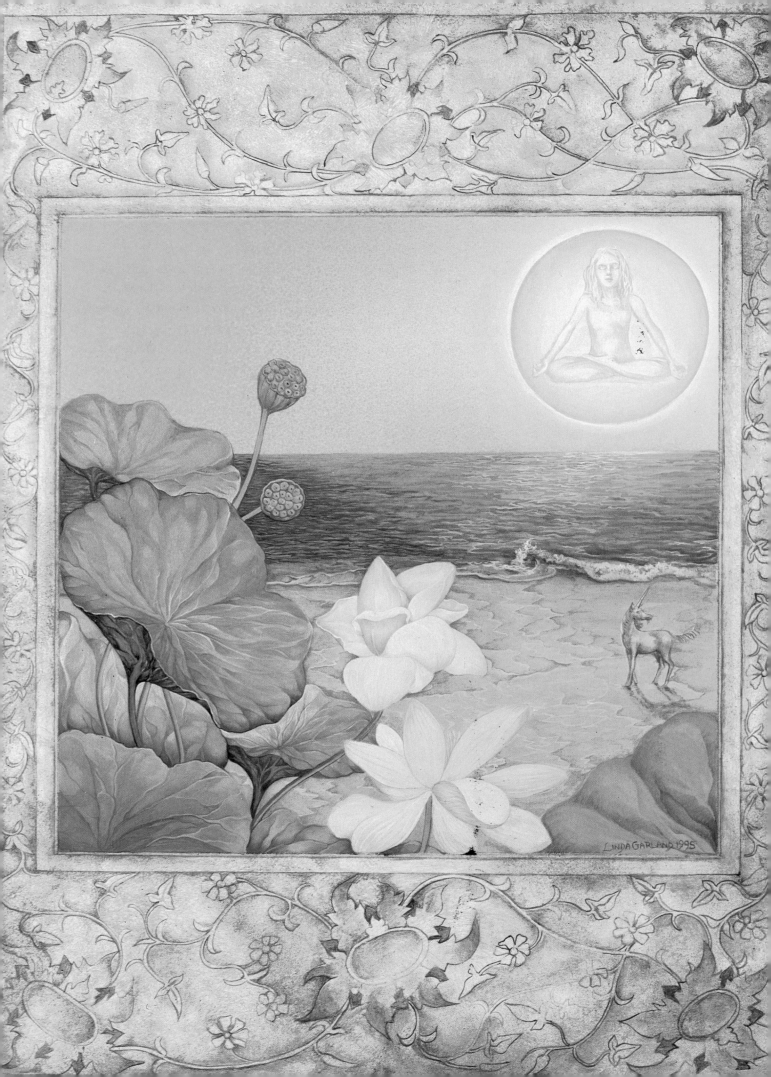

The Unicorn Hermit of India

Long ago, deep in the Indian jungle, there lived a hermit called Vibhandaka, whose name means Unicorn. He lived all alone and his only visitors were people from the nearest village who occasionally came with offerings of food for their holy man. His real disciples were the birds and beasts who came to bathe in the glow of his serenity as he sat cross-legged in the mouth of his cave, meditating on the mysteries of the universe.

One animal in particular, a female gazelle, became his constant companion. She grew so enamoured of him that, in time, she miraculously conceived and gave birth to a child. The boy was human in every way, apart for the single horn that grew from the centre of his forehead. He was named Rishyashringa, which means Gazelle's Horn.

Rishyashringa also became a hermit and under the tutelage of his father went on to study and master even greater mysteries. Animals flocked to him and he seemed able to speak to each in its own tongue and even the trees and flowers seemed to bend to listen. It was also rumoured that the sky and the rain were his friends, keeping the area where he lived green and fertile.

After some time a terrible drought seized the country and people believed the gods had deserted them because their ruler had fallen into evil ways. When their mutterings reached the Rajah's ears, he began to fear for his life and called all his wise men together to ask what he should do. None dared suggest he mend his ways and make peace with Heaven, but one Brahmin had an idea. Stepping forward and bowing low, he said, 'Most illustrious and all-powerful master, there lives in a far corner of your kingdom a holy man on whom, it is said, the grace of the gods still falls. Where he dwells there is still rain in abundance and the earth brings forth every kind of fruit. The beasts grow fat and sleek there while everywhere else they are dying of thirst and hunger. If anyone can end this drought it is he. Only have him brought here to the heart of your kingdom and I believe our troubles will be over.'

So the Rajah sent messengers to Rishyashringa inviting him to the palace, but they returned alone, saying that the sage had only smiled at their request. Then the Rajah sent soldiers, telling them to use force if need be. They, too, came back empty-handed, saying they could not bring themselves to lay hands on the saint, even though he had offered no resistance. The Rajah had them flogged and thrown into prison before summoning the most loyal of his bodyguards. 'Bring me this hermit,' he commanded them, 'and if you also fail I will have you trampled by elephants under the eyes of your loved ones.'

Then the Rajah's daughter, Shanta, spoke up, 'Father, let me go instead. I will

◄ *Buddha's creature*

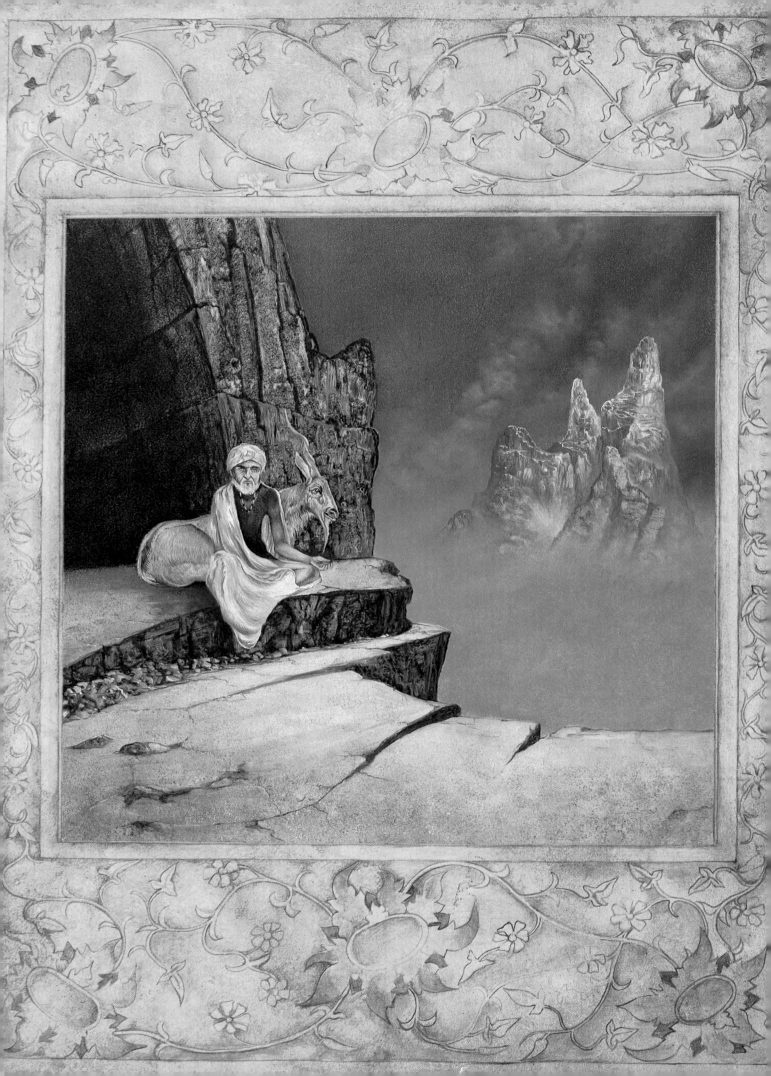

persuade the hermit to come. If you force him against his will it can only bring worse luck on us all.'

Seeing the sense of this, her father agreed and, after making a sacrifice to Ganesh, the elephant-headed god of successful enterprises, the princess set off with her retinue.

Riding in a howdah on the back of her favourite elephant across the wide, dusty plain, Shanta saw evidence of the drought on all sides and her heart bled for the people's plight. Her father only feared their wrath, but she pitied them and this stiffened her resolve to do what she could to end the kingdom's troubles.

In time the mountains where Rishyashringa lived drew near, looking green and lush beyond a broad, though much shrunken, river. Here, Shanta left her followers at a distance and went on alone, crossing the water on a raft roped to both banks. Following directions she had been given, she came finally to a cave in front of which the hermit was sitting in the lotus position, deep in meditation. Around him various birds and beasts were gathered and Shanta noticed that in his presence the hunter and the hunted took no notice of each other. She saw, too, that Rishyashringa was much younger than she had expected and beautiful in face and limb. Even the single horn projecting from his brow seemed a mark of distinction and she longed to touch it.

Approaching quietly, she knelt before the hermit and waited. It was a long time before his eyes opened and when they did

he smiled. She immediately fell in love with him and wanted nothing more than to spend the rest of her life by his side. However, she did not completely forget her purpose and all the starving people she had passed. She even thought of the wicked old Rajah who, for all his sins, was still her father and had a place in her heart. So she smiled back, not as a supplicant or a disciple or a love-struck maiden but with all the confidence of a beautiful young woman.

The hermit was dazzled. Never before had he seen or even imagined an earthly creature such as she. So at first he took her for an angel from heaven.

'Master,' said the princess, 'my father's kingdom has need of you.' With that she rose and walked slowly back towards the river, with all the grace of a gazelle. When she passed from sight Rishyashringa could not help himself. He rose and followed her as if in a trance. Seeing the trace of her footsteps on the ground, he now knew that she was not a spirit but still he followed, thirsty for another glimpse of her.

Without looking back, Shanta threaded her way down through the forest to the river. When she reached it, she still did not turn, but sat down on the raft, gazing at the far bank as if lost in thought. This indifference was entirely affected but Rishyashringa had no notion of this. As he watched from the shelter of the overlooking trees her motives were a closed book to him. For the first time in his life, his heart and loins tingled with desire for another human being. Even his spirit, usually

◀ People believed the gods had deserted them

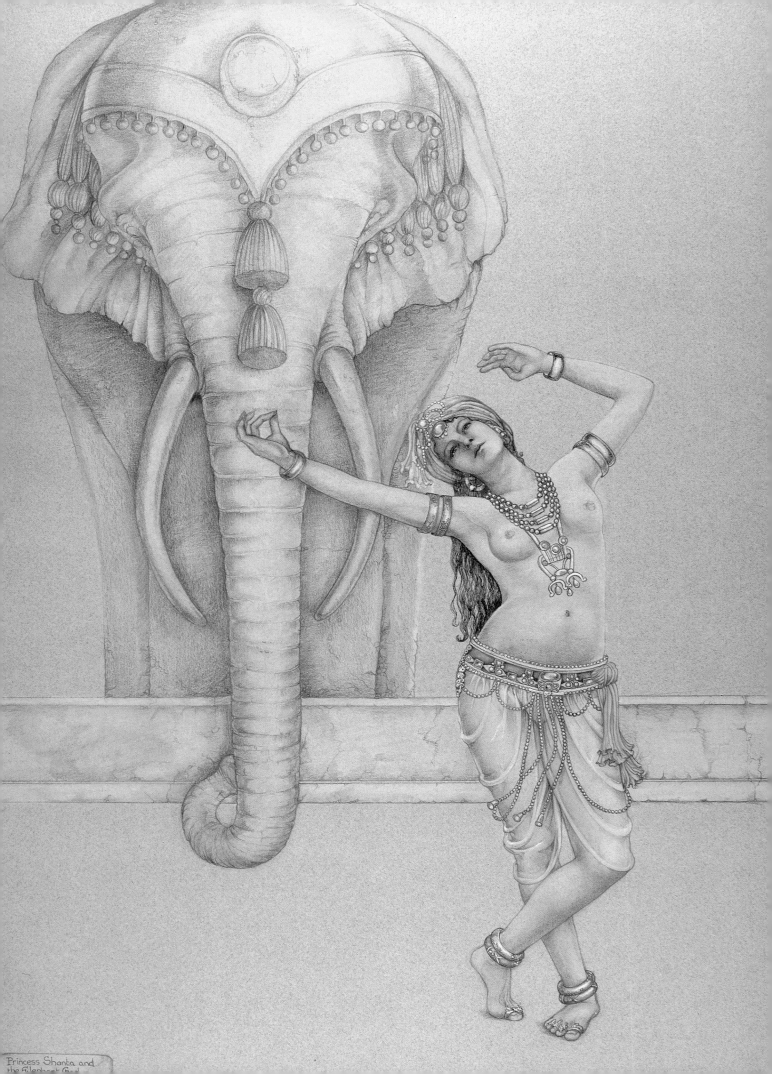

Princess Shanta and
the Elephant God

dedicated to pursuits of a higher plane, was suddenly eager to unravel the mystery of the maiden's charms.

Behaving as though she thought herself alone, Shanta undressed and bathed in the river and then relaxed on the raft to dry in the sun. There, she seemed to fall asleep. When at last she opened her long-lashed, almond shaped eyes, it was to find the hermit kneeling beside her in reverence, just as she had earlier knelt by him. With one crimson-tipped foot she pushed the raft off from the shore.

As the princess made her way back across the kingdom with Rishyashringa, clouds gathered overhead and rain began to fall. By the time they arrived at the palace the drought was broken and they were greeted by tumultuous crowds.

Abandoning his former existence, Rishyashringa married the princess and in due course became king himself. However, even before this his influence was such that the old Rajah saw the error of his ways. He began to dispense justice and bounty with such a free hand that when he died he was as much mourned by his people as he had formerly been hated.

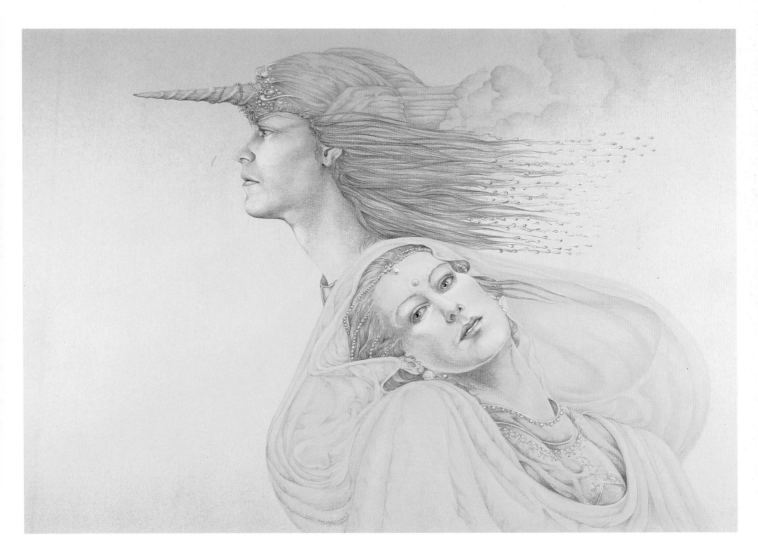

▲ *Breaking the drought*
◀ *Dance prayer to Ganesh*

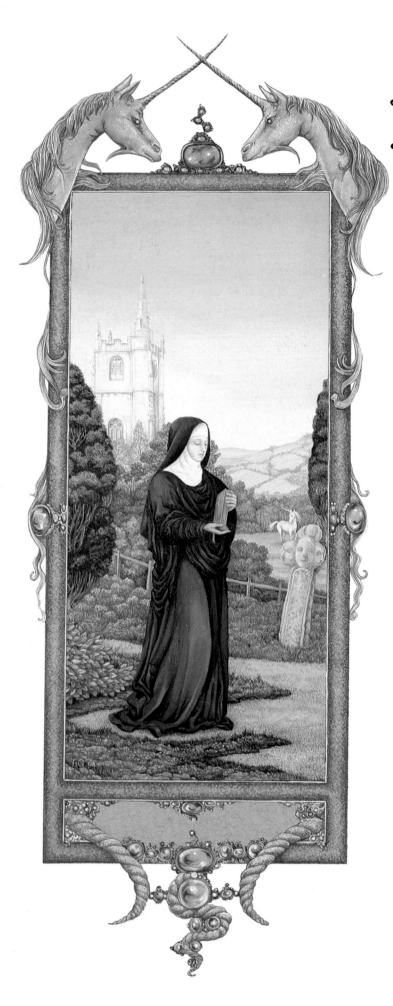

CHAPTER 2
Unicorns

Unicorns are rare in legend and almost as rare in modern fiction, but when it comes to the lore of the Unicorn we are on firmer ground. Snippets of information and travellers' tales are scattered throughout ancient literature, and it is the echoes of these that are largely responsible for keeping the image of the Unicorn bright down to the present day. In the West, Christianity helped by adopting the creature as an icon, and heraldry can fairly claim much of the rest of the credit.

Sadly, there is no great treatise by anyone claiming firsthand and intimate knowledge of Unicorns. There are many claimed encounters with them, some quite believable, but none that do more than whet our curiosity. What we do know is owed largely to scholars occasionally gathering together all the second- and thirdhand information they could find.

This will come as no surprise to the modern sceptic but, as it happens, the Unicorn is not a totally improbable creature. There remain some surprisingly

in the West

sound arguments in favour of it having some basis in reality. There is, it is true, a glaring absence of Unicorns in our zoos and museums, but not all the claimed sightings over the ages can be lightly dismissed. Nor have such claims entirely died out.

As a quixotic venture, a fair case could still be made for the reality of Unicorns. Don Quixote himself would surely approve as he considered adopting the Unicorn in his title before settling for the Knight of the Doleful Countenance. One could argue that it has never been in the Unicorn's own interest to have its habits and whereabouts widely known, and that its friends would naturally keep quiet about it. If nuns and pagan priestesses were its guardians in olden times, they would hardly have wanted to broadcast anything that would lead hunters to the Unicorn. One might propose that even if most of what has been said about Unicorns is true, we would still have no more evidence than we do.

However, it is unnecessary. You do not have to believe in Unicorns to be interested in them. What is special is the niche they occupy in our imagination. The lore of Unicorns is fascinating in itself, and much of it is centred on the Unicorn's singular and startling horn.

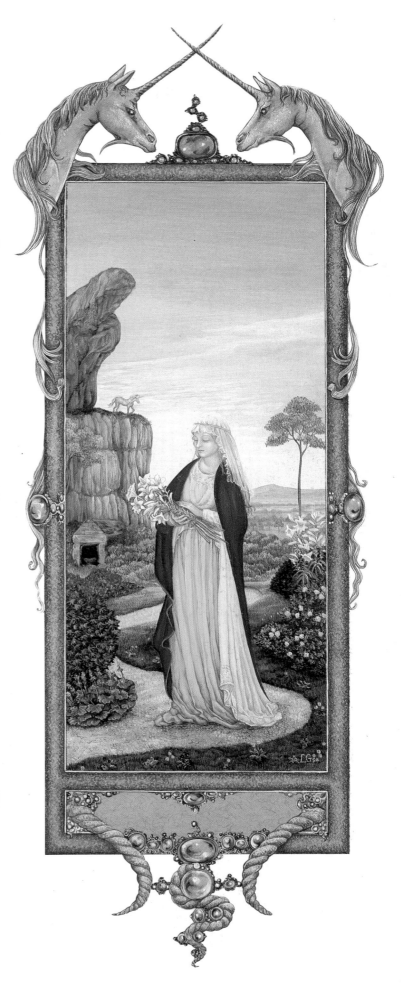

The Wondrous Alicorn

 he Unicorn's horn, or Alicorn, has been its glory and its downfall. From the earliest times and in all parts of the world animal horns of all kinds have been accorded medicinal and even magical properties. One has only to look at the horn symbolism in the Bible to sense their significance in cultures closer to nature than ours. Even today, throughout much of the world, powdered horn is sold to remedy a host of illnesses – but none, not even that of the rhinoceros, has ever rivalled the healing virtue attached to Alicorn.

In the sixteenth century the accumulated wisdom of the ages was summed up by Dr Conrad Gesner of Zürich as follows: 'This horn is useful and beneficial against epilepsy, pestilential fever, rabies, proliferation and infection of other animals and vermin, and

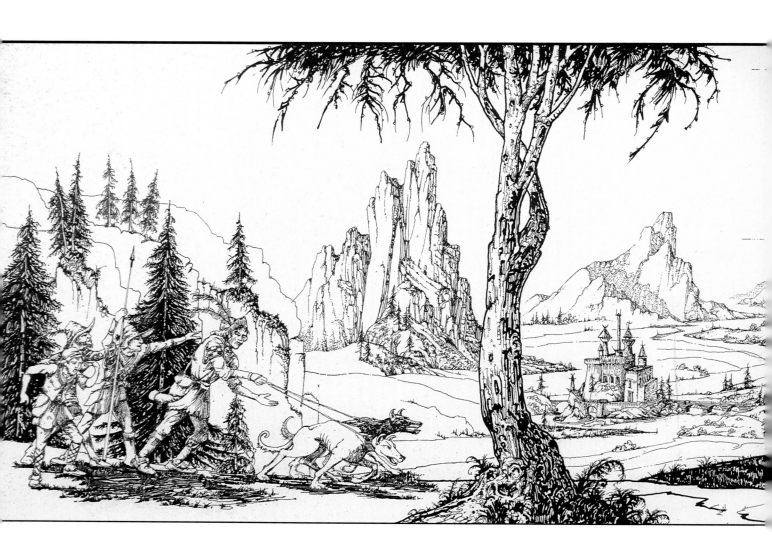

against worms within the body from which children faint. Ancient physicians used their Alicorn remedies against such ailments by making drinking mugs from the horn and letting their patients drink from them. Nowadays such drinking vessels are unobtainable and the horn itself must be administered [as a powder] either alone or mixed with some other drug.... Genuine Alicorn is good against all poison; especially, so some say, the quality coming from the Ocean Isles. Experience proves that anyone having taken poison and becoming distended thereby, recovered good health on immediately taking a little Unicorn horn.'

In the mere presence of poison a piece of Alicorn is said to sweat and change colour. If a piece of horn is dipped into poison, or poison is poured into an Alicorn cup, the Alicorn will effervesce and neutralize the poison, or at least reduce its efficacy. The basis for this belief is the old story of how the Unicorn used its horn to purify spring water so that other beasts might drink. This is the main reason it was prized in the past by kings and scholars who had read of its power in obscure tomes. For the majority, however, Alicorn was so scarce that for most people it might as well have not existed.

In the Middle Ages the supply of Alicorn suddenly increased and every report of a sighting of a Unicorn was eagerly pursued by hunters after the treasure on its brow.

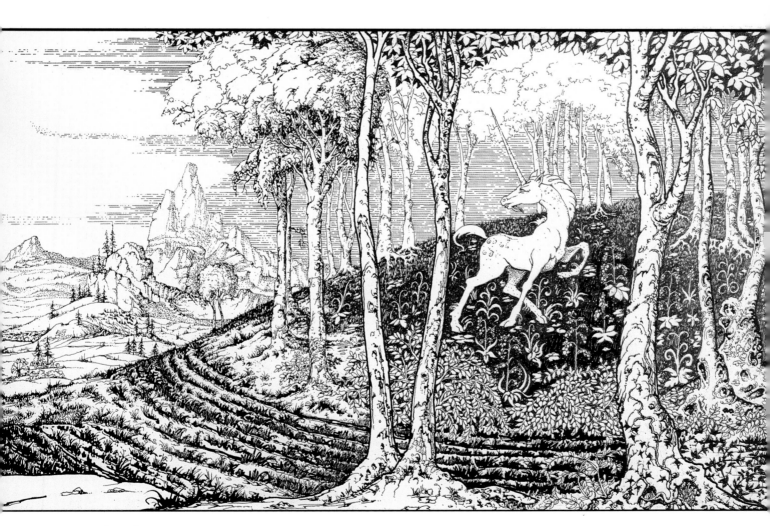

▲ *The Chase*

To be fair to the hunters, we must remember that Medieval attitudes to animals differed widely from those of today. Animals were thought to have been put on the earth for humans to use and abuse as they chose. To many people the Unicorn was no different, even though it was the first animal God had named in Eden. There was also, at that time, a very real and widespread fear of poisoning and no effective means of detecting it, other than using the Alicorn. Great advances in the sophistication of poisons increased the demand for Alicorn, which thankfully coincided with its greater availability.

Drinking from an Alicorn cup was the best way to protect oneself, and some princely examples survive to this day. In addition to guarding against poison they were said to enhance the happiness, health and long life of the user. Failing this, a slice or sliver of horn could be just as effective, and many wealthy people wore these on gold or silver chains around their necks. To detect poison in solid food, those who could afford it had cutlery with Alicorn handles. Some considered that it was enough merely to have an Alicorn ornament in the middle of the table, and of these too there are some wonderful medieval examples.

The sixteenth century saw the height of demand for Alicorn in Europe, and every noble of any standing had at least one piece of it secured somewhere about his person or on his dinner table. Complete horns were still rare, though, and immensely valuable. Even powdered horn sold for up to ten times its own weight in gold, and complete horns were said to be worth the value of an entire town.

▲ *The Unlikely Ones*

For example, in 1550 Pope Clement paid 17,000 ducats for 'the most beautiful Unicorn's horn that was ever seen'. It was elaborately mounted in gold and silver before being presented to King Françoise of France. In 1584 the Russian Emperor Theodore Ivanovitch carried an imperial staff at his coronation which incorporated an Alicorn 3.5 feet long, bought for 7,000 silver marks from the merchants of Augsburg.

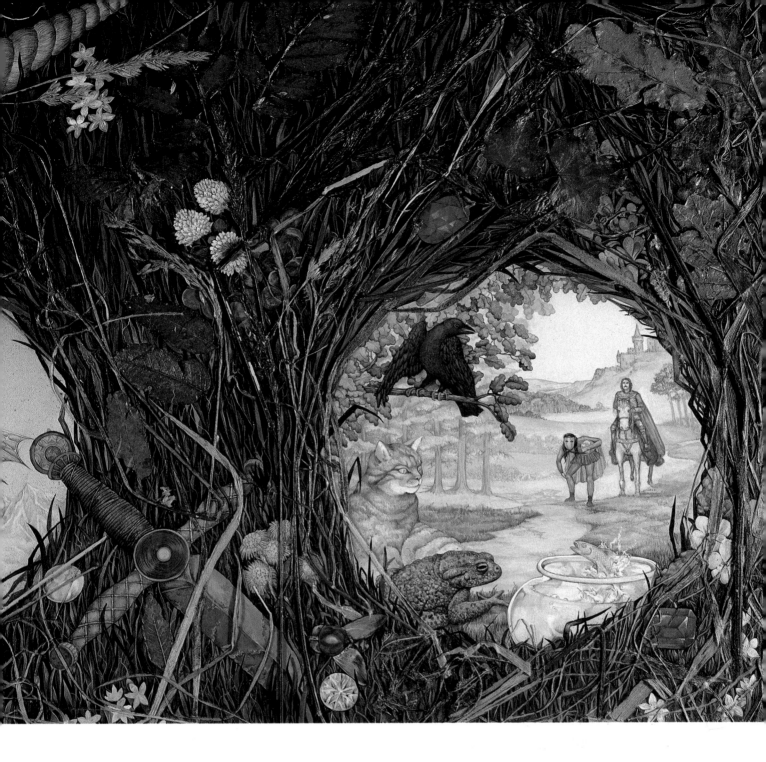

The most famous British Alicorn was that belonging to Queen Elizabeth I and listed among her crown jewels as the Horn of Windsor. It was valued at £10,000 (about £10,000,000 by today's prices). Another Alicorn, known as the Tower Horn, was described by Edward Topsell in his famous *History of Four-Footed Beastes*: 'I never saw anything in any creature more worthy of praise than this horn. The substance is made by nature, not art, wherein all the marks are to be found which the true horn requireth. It is of so great a length that the tallest man can scarcely touch the top thereof, for it does fully equal seven feet. It weigheth thirteen pounds, being far more thicker from one part, and making itself by little and little less towards the point. The splents of the

spire are smooth and deep, being for the most part like unto the wreathing turnings of snails, or the revolutions or windings of wood-bine about any wood. But they proceed from the right hand toward the left, from the beginning of the horn even unto the very end. The colour is not altogether white, being a long time somewhat obscured.'

Elizabeth's successor, James I, paid £10,000 for another horn which turned out to be a fake. As a test, he added the powdered horn to a cup of poison and offered it to his servant to drink; the poor man promptly dropped dead.

Times and values change. To James, the horn immediately became almost worthless, whereas in 1994 a fake Unicorn's horn was auctioned at Christie's in London for nearly half a million pounds. Although it was recognized as a twelfth-century fake, some Unicorn magic seems to have been appropriated over the ages. David Ekserdjian, head of Christie's sculpture department, gave his first impressions: 'It was wrapped up in newspaper inside a cardboard tube, but the minute I held it in my hand I knew I was in the presence of a great and extraordinary object. There was something about its weight and heft, as well as the sheer beauty of its carving. It has an almost tangible power, something you can feel coursing through your veins.'

Or perhaps it was not a fake.

For commoners, who had no chance at all of owning an Alicorn, their only opportunity to see or benefit medicinally from the horn was when one was owned

by the Church and put on public display. The most famous of these belonged to the Church of St Denis near Paris where it was kept in the vault. One end was placed in a font and the water was dispensed to the sick and infirm. It apparently cured a wide variety of illnesses after initially inducing a fever. Its description almost exactly matched Topsell's description of the Tower Horn. Unfortunately, it disappeared during the French Revolution.

St Mark's in Venice possessed three famous Alicorns, as did Milan Cathedral, St Paul's Cathedral and Westminster Abbey in London, and several others. Chester Cathedral in England still boasts an Alicorn among its treasures, while the horn auctioned at Christie's may once have belonged to Hereford Cathedral. It was bought for a pittance in the 1950s as one of a bundle of walking sticks cleared from a property in the cathedral close.

As the price of Unicorns' horns went through the roof in the Middle Ages, so too did the stakes for forgery. Many tests were devised to detect the true article which were not as drastic as that devised by James I. David de Pomis, writing in Venice in 1587, says: 'The common test which consists in placing the object in water to see whether bubbles rise or fall is not at all to be trusted. Therefore, wishing to benefit the world and expose the wicked persons who sell worthless things at great prices, I take this occasion to describe a true test by which one may know the genuine horn from the false. The test is this: Place the horn in a vessel of any sort of material

you like, and with it three or four live and large scorpions, keeping the vessel covered. If you find four hours later that the scorpions are dead, or almost lifeless, the Alicorn is a good one and there is not money enough in the world to pay for it. Otherwise it is false.'

Laurens Catelan, a prominent physician who possessed a full Alicorn himself and had presumably put that to the test, published five tests for true horn in Montpelier in 1624. For him the water test worked; indeed, the water seemed to boil when touched with true horn. Poisonous plants and animals burst and died when brought near it; it sweated in the presence of poison and gave out a sweet odour when burned.

Another test involved drawing a circle on the floor with a piece of Alicorn or with water into which it had been dipped. Then a spider was set inside the circle and if it would not cross the line but preferred to starve to death, then the horn was real. Dr Conrad Gesner of Zürich gets closer to the scientific method when he recommends: 'Give some arsenic to a pair of doves, and give one of them a short drink of Unicorn horn. If this dove remains alive, the horn is genuine and the other dove will die. Wealthy people may well use this test if they wish, since Unicorn horn is so expensive.'

This test survived the close scrutiny of the College of Physicians in Copenhagen in 1636, but sadly failed when applied to two kittens.

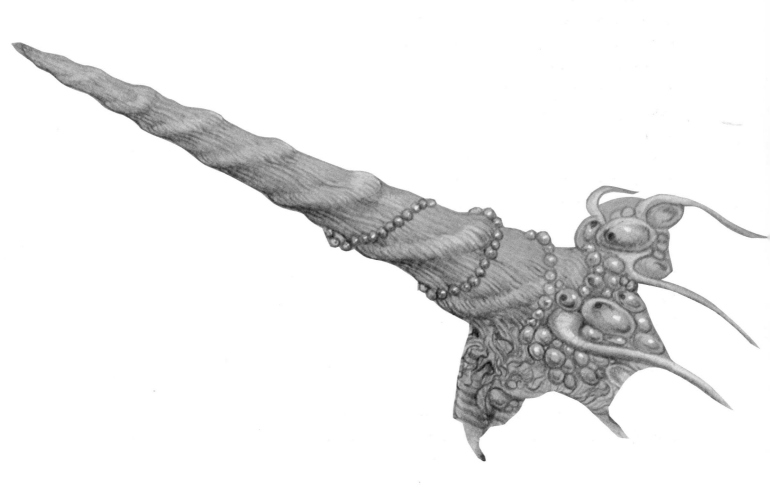

False Horn

 s with splinters of the True Cross and thigh bones of St Paul, sadly, it is safe to say that most of the Unicorn horns in circulation during the Middle Ages were fakes. Substitutes for powdered Alicorn were made from a variety of burned horns and bones mixed with limestone and clay and often steeped in perfume to meet the various tests for authenticity. Stalagmites and fossil bones were often passed for 'fossil Unicorn horns'. And before the thirteenth century rhinoceros horns often passed for the real thing, thanks to a degree of confusion between the two beasts created by Pliny and other ancient authorities.

Complete horns were often faked using carved ivory, and there are reports of elephant and walrus tusks being artificially straightened for this purpose. A famous sixteenth-century traveller, Andre Thevet, witnessed this operation taking place on an island in the Red Sea, from where the false Alicorns were exported both east and west.

Supreme among fakes, though, was the narwhal horn, and once it made an appearance in about the twelfth century it

▲ *Decorative horn*

forced out all rivals. Many people have assumed that the narwhal horn is the inspirational source for the characteristic spiral of the Unicorn's horn, now an essential part of all artistic representations. However, there are pictures of Unicorns with straight, spiralling horns dating from well before the first known or likely imports of the narwhal horn.

The narwhal's horn is in fact a tusk which grows from the front of its jaw, not from its forehead. It is an extreme elongation of one of the male's front teeth and grows up to nine feet long, which is more than half of an Arctic whale's body length. Its purpose, as far as anyone knows, is to break through surface ice.

Ultimately, whether it was tusk or horn hardly mattered in the Middle Ages. What counted was the shape.

Most of the renowned medieval Alicorns that have survived are undoubtedly narwhal fakes. They were supplied throughout Europe, and also to the East, by Scandinavian fishermen who discovered the narwhal off the coast of Greenland. They managed to preserve their lucrative secret for the next 400 years, because the narwhal rarely swam south.

An indication of the enormity of their trade is revealed in an account of a twelfth-century shipwreck off the west coast of Iceland, from which Arnhold, first bishop of that country, narrowly escaped with his life. So many sailors lost their lives and were found washed up in marshlands by the shore that the area subsequently became known as the Pool of Corpses. And

for every drowned sailor there was a narwhal tusk bearing his name inscribed in red runes.

Considering how many other shipments must have got through, what is surprising is how few complete tusks appeared as Alicorns in Europe. After 500 years of the trade there were still fewer than two dozen that we know of. This is astonishing when you consider that one successfully smuggled tusk could have set a sailor up in luxury for life. If one pieced together all the scraps made into cups, plates, cutlery, table ornaments and amulets, the total would be much greater; and to this we must add all that was ground to powder. But what emerges is still a picture of enormous restraint. The kings of Denmark, who controlled the trade, may have indulged themselves with a throne of Unicorns' horns, but they took care that no other king could afford to do the same.

The bubble burst in the seventeenth century when the truth of the matter emerged as a result of growing trade between Greenland and North America. Despite much resistance from those who really believed in the power of the Alicorn as well as those with a financial stake, the price of Alicorn began to plummet. It continued to appear in lists of scientifically approved medicines until well into the next century. However, the recorded price in, for example, Frankfurt apothecary shops fell from 128 florins an ounce to just 8 between 1612 and 1669. One complete horn belonging to Charles I fell in value from £8,000 in 1630 to just £600 in 1649.

Curiously, exposure of the narwhal tusk fraud didn't lead to an immediate reappraisal of belief in the Unicorn. The seed of doubt was planted, but it was to be almost 200 years before it gained any real momentum. The immediate effect was simply to re-establish Unicorns' horn as a rare commodity.

◄ *Hunting the Narwhal*

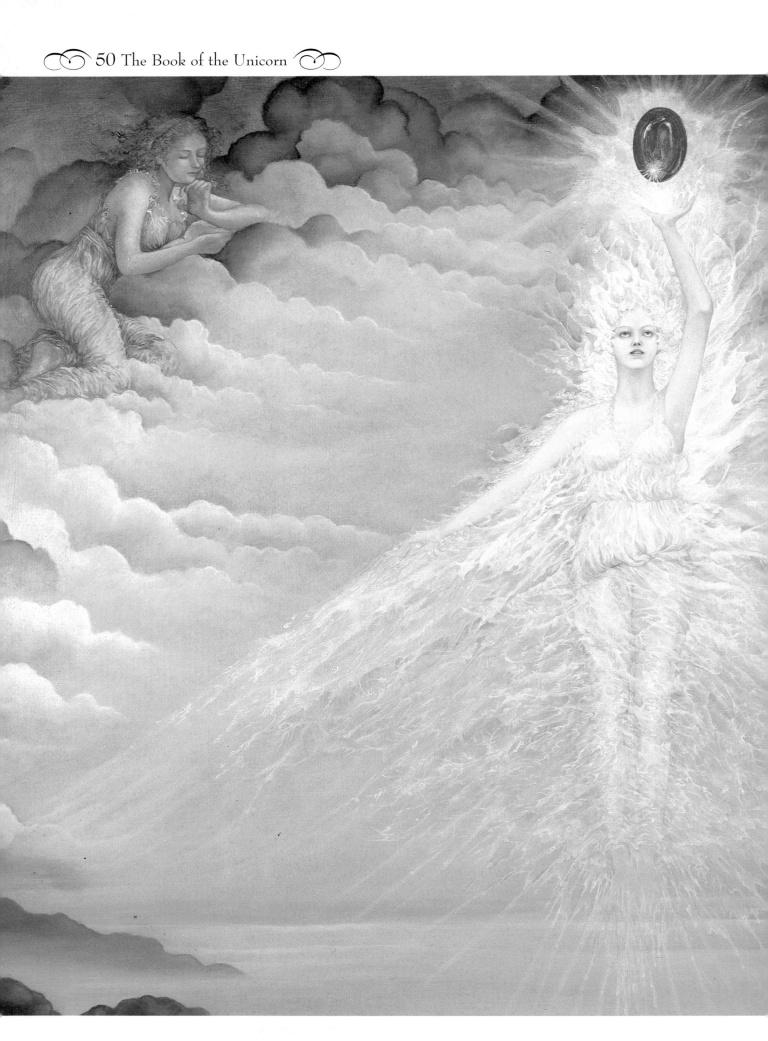

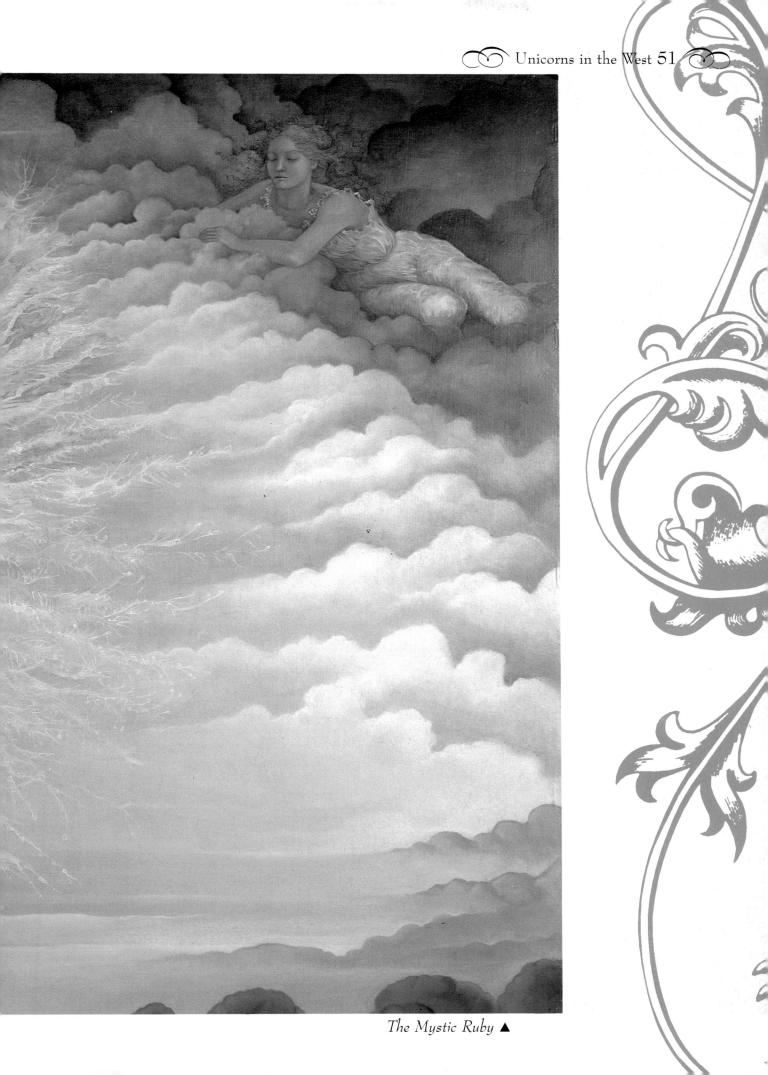

The Mystic Ruby ▲

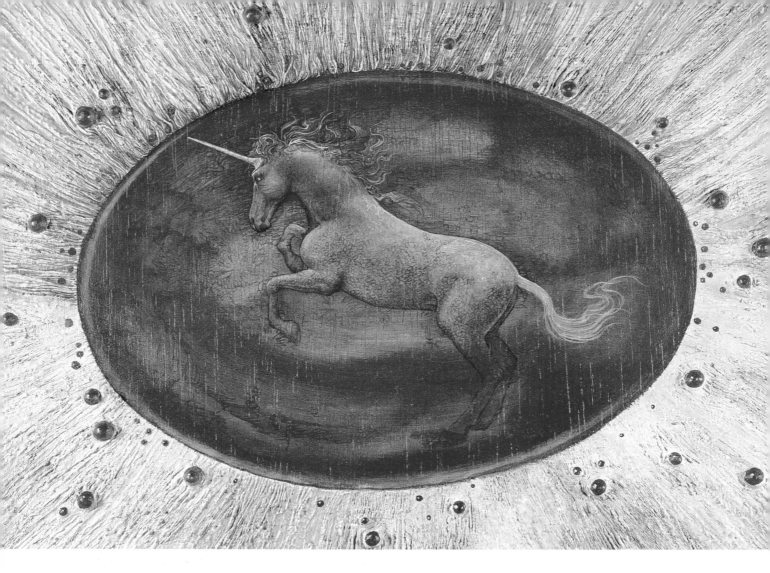

The Mystic Ruby

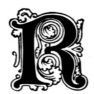arer still than true Unicorns' horn is the mystic ruby, also called a carbuncle, rumoured to be found at the horn's base. Some authorities have held the jewel to be the source of the horn's powers. However, as it has not been found consistently in all Unicorns, it is possible that the 'ruby' is some kind of distillation of the concentrated essence of the horn. It

may, perhaps, only occur in very old or wise Unicorns and be caused by a crystallization of blood. Albertus Magnus, alchemist and one of the most influential thinkers of the Middle Ages, believed the 'male carbuncle' to be the king of gems, able to dispel poison, guard from plague and banish sadness, evil thoughts and nightmares. It could be employed as either an amulet or a powder and a good stone would shine so brightly of its own accord as to be visible through clothing.

The stone is mentioned in several of the romances about Alexander the Great. In the Song of Alexander by Pfaffen Lamprecht in the twelfth century we hear of a gift from Queen Candace to the conqueror:

I had from this most wealthy queen
A beast of proud and noble mien
That bears in his brow the ruby-stone
And yields himself to maids alone.
But few such Unicorns are found
On this or any other ground,
And only such are ever captured
As pure virgins have enraptured.
No man yet of woman born
Endures the terror of his horn.

In Wolfram von Eschenbach's *Parzifal*, it is said of one of the remedies applied to the Grail King's wounds (in vain as it happens, since nothing but the attainment of the Grail can do that):

We caught the beast called Unicorn
That knows and loves a maiden best
And falls asleep upon her breast;
We took from underneath his horn
The splendid male carbuncle stone
Sparkling against the white skull-bone.

In *Parzifal* it is mentioned that the Unicorn's heart was also used as a medicine. The twelfth-century Abbess Hildegard of Bingen went even further. Drawing largely on Arabic lore, she found medicinal value in almost every part of the poor creature's body, and provided recipes accordingly:

'Take some Unicorn liver, grind it up and mash with egg yolk to make an ointment. Every type of leprosy is healed if treated frequently with this ointment.

'Take some Unicorn pelt, from it cut a belt and gird it round the body, thus averting attack by plague or fever.

'Make also some shoes from Unicorn leather and wear them, thus assuring everhealthy feet, thighs and joints; nor will the plague ever attack those limbs.

'Anyone who fears being poisoned should place a Unicorn hoof beneath the plate containing his food, or the mug holding his liquor. If warm food and drink are poisoned, the hoof will make them effervesce; if they are cold it will make them steam. Thus one can detect whether they are poisoned or not.'

Hildegard, also known as the 'Sybil of the Rhine' on account of her many recorded visions, knew also of the jewel at the base of the Unicorn's horn, though she describes it as being clear. She seems to have had no qualms about hunting the Unicorn to death, beyond warning that if it detects a false maiden in the trap it is likely to gore her (or him) to death. The Unicorn's matchless strength she attributes to its yearly custom of visiting the site of the Garden of Eden where the waters of Paradise flow: 'There it seeks out the best herbs and vegetables, paws them loose from the soil, and devours them.'

She set all this down in a volume called the *Physica* in which she also tells the tale of a naturalist who had searched for the Unicorn in vain for many years. One day he is invited to a large gathering in the countryside, from which several young ladies break away to picnic and amuse themselves among the flowers. Happening to stray after them, the naturalist's long search was at last rewarded as he stumbled upon a Unicorn transfixed by the sight of the maidens at play. For, as Hildegard says of Unicorn susceptibility: 'If, moreover, two or more girls are together, he is still more astonished and can be caught all the more easily as he sits there staring at them as though turned to stone.'

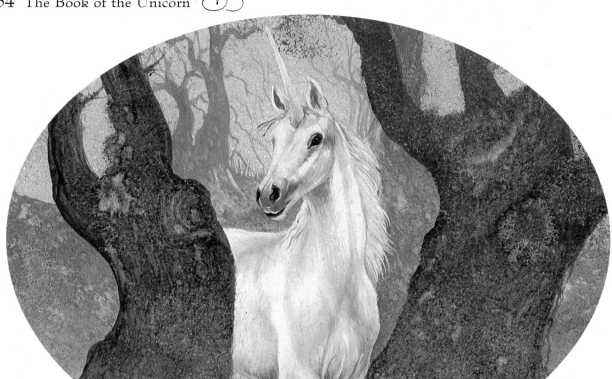

Ancient Authorities

he high Middle Ages marked the height of the Unicorn's renown in the West. The Unicorn is often thought of as a figment of the Medieval imagination, but there are scattered references to it from long before then. Julius Caesar, for example, tells us, in his account of the conquest of Gaul, of various strange creatures said to inhabit the vast Hercynian forest of Germany, including: 'An ox shaped like a stag from the middle of whose forehead, between the ears, stands forth a single horn, taller and straighter than the horns we know.'

The earliest recorded mention of the Unicorn in Western literature is by Ctesias of Cnidas, who went to Persia in 416 BC to serve as court physician, firstly to Darius II, and then to Ataxerxes. Surviving the intrigues of the Persian court, he returned to Greece some seventeen years later and whiled away a comfortable retirement in the Peloponnesus recording all he had seen and heard. He wrote mainly about Persia but he also compiled an account of India gleaned from the tales of envoys, merchants and other travellers whom he considered reliable.

Megasthenes' account of India ▶

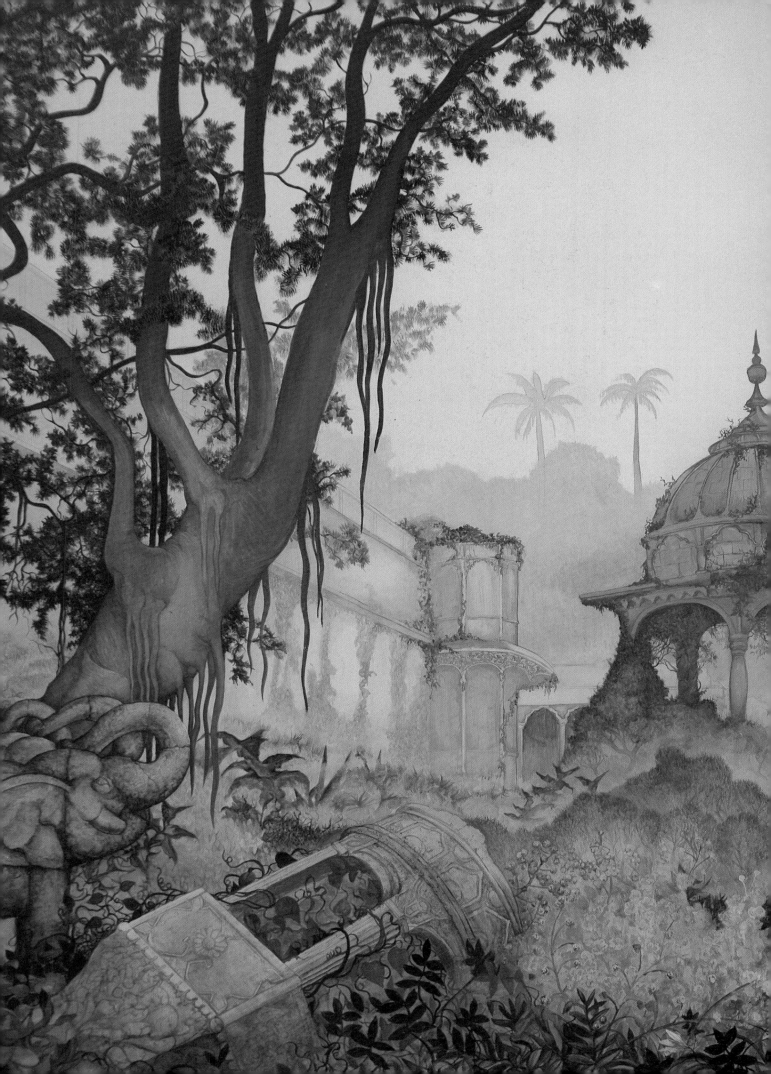

He includes a description of a creature he, and many others independently, call the Indian wild ass, which was roughly the size of a horse: 'Their bodies are white, their heads brown and their eyes dark blue. They have a horn on their forehead which is about a cubit long. The dust filed from this horn is administered in a potion as a protection against deadly drugs. The base of this horn, for some two hands' breadths above the brow, is pure white; the upper part is sharp and of a vivid crimson; and the remainder, or middle portion, is black. Those who drink out of these horns, made into drinking vessels, are not subject, they say, to convulsions or epilepsy. Indeed, they are immune even to poisons if, either before or after swallowing such, they drink wine, water or anything else from these beakers. The animal is exceedingly swift and powerful so that no creature, neither the horse nor any other, can overtake it.'

Apart from the colouring, Ctesias is describing a beast uncannily similar to the Unicorn as it was to be depicted some two thousand years later in European tapestries. In fact, several of these tapestries do show the beasts with variously tinted and dappled bodies. The colouring of the horn is the most glaring discrepancy. It has been suggested that Ctesias embroidered the hearsay account with a description of painted Unicorn beakers he had seen in Persia. This is quite possible, but it may be that in India such colouring was a natural variation. Aristotle and Herodotus also give casual mention to the one-horned 'wild ass', as if belief in its existence was quite common in the East.

The next significant description comes a century after Ctesias from another Greek, Megasthenes. He was a high-ranking official who was despatched to India as an envoy for Seleucis I, one of Alexander the Great's successors. On his return he wrote a description of India in four volumes which formed the largest body of knowledge about the country available in the West. He did not see the Unicorn firsthand, but passes on a description he had from some Brahmins. Sadly, they seem to have been confused in their own minds between the wild ass and the rhinoceros, which Megasthenes describes elsewhere quite accurately.

According to the Brahmins, the Cartazoon, as they called it, was the size of a horse, pale brown and maned. Its horn was black, spiralling, grew from between the eyes and was extremely sharp and strong. The beast is gentle to other creatures but fierce towards its own kind, except during breeding, because it loves solitude. Adults are too fierce to be captured but the young are sometimes displayed at palace festivals. Unfortunately, at this point the description stops mirroring our romantic idea of the Unicorn and finishes on rather an alarming note: 'it has a curly tail like a hog and feet like an elephant.'

The Cartazoon was witnessed firsthand by Apollonius of Tyana, the renowned mystic and Pythagorean, who derived much of his wisdom from the yogis of India. According to his biographer, Philostratus, he saw some Unicorns captured near the River Hydaspes, or Beas, the limit of Alexander's venture into that country.

He heard also how the kings of India had cups made of the horns from the creatures' brows, in the belief that whoever drank from one was immune to poison or pestilence for the day. When asked by a disciple if he believed this, Apollonius replied, 'I would be inclined to believe it if I had heard that the kings of these Hindus were immortal, for would one who can offer me or anyone else so healthy and therapeutic a draught have any reason not to draw it for himself every day, and drink from such a horn to the verge of intoxication?'

At about the same time in the first century AD, Pliny the Elder unintentionally muddied the water a little by calling the rhinoceros by its Greek name, the monoceros. Since then he has been considered to be one of the early authorities on the Unicorn. In the Middle Ages his word was taken almost as gospel, even though it was plain to anyone with half an imagination what he was really describing: 'The Orsean Indians hunt an exceedingly wild beast called the monoceros which has a stag's head, elephant's feet and a boar's tail,

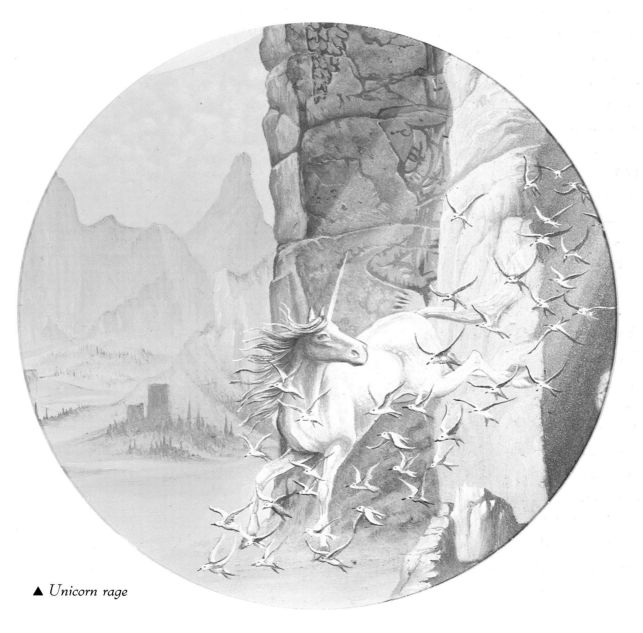

▲ *Unicorn rage*

the rest of its body being like that of a horse. It makes a deep lowing noise and one black horn two cubits long projects from the middle of its forehead.'

So, beyond giving it a name, Pliny cannot be said to have furthered the cause of the Unicorn much. That was left to his fellow Roman, Claudius Aelianus, or simply Aelian, in the following century. Aelian never left Italy and so had no first hand experience to offer, but he was an avid encyclopedist whose study of natural history, *De Animalium Natura*, was widely respected. Drawing largely on Ctesias and Megasthenes, amongst other sources, he collated all the Greek Unicorn lore, and his writings were second only to those of Aristotle and Pliny in shaping the views of later zoologists.

Elaborating on the use of horns as drinking cups he says, 'Only the great men use them after having them ringed with hoops of gold exactly as they would put bracelets on some beautiful statue.' He tells also of the Unicorn's style of combat, using teeth and heels as well as its horn. The animal defended itself so fiercely that in India the phrase 'hunting the Unicorn' was another way of saying 'chasing the unattainable.' In addition he has much to say about the astragalus, or ankle-bone. In the ancient world such bones were widely used as charms and dice and, in the Unicorn's case, were considered almost as precious as the horn.

In the absence of many actual sightings it was from such written, and doubtless verbal, accounts that the legend of the Unicorn spread through Europe in the early days. But these were mostly just travellers' tales about an exotic creature in far-away countries. It is likely that the Unicorn would have long escaped general notice were it not mentioned in the Bible and often quoted in the teachings of the Church.

In the King James Bible, the references to Unicorns occur in Numbers 23:22; Deuteronomy 33:17; Job 39:9-12; Psalms 22:22; Psalms 29:5-6; Psalms 92:10 and Isaiah 34:7. They emanate from the Septuagint translation dating from the third century BC, when Ptolemy II of Egypt commissioned seventy-two Jewish scholars to produce a Greek version of the Old Testament in as many days. He kept them imprisoned for the duration of their task on the island of Pharos near Alexandria.

They chose to translate the Hebrew word Re'em as Monoceros, which is Greek for Unicorn. Modern scholars believe that the choice of the word Monoceros was an error. The translators did not know what was meant by Re'em, so cast about for some creature that fitted the description in the Bible: mighty, hostile to lions, fleet-footed, horned and untamable. The Unicorn fitted the description and was, to the best of their knowledge, a living creature.

We now know that the Re'em was a species of giant, wild ox; from fossil evidence it was about fifteen feet in length and ten feet tall. It was also known as the aurochs or *Bos Primogenitus*, and is believed to have become extinct about 1,200 years before the Septuagint was begun.

Magic drinking horn ▶

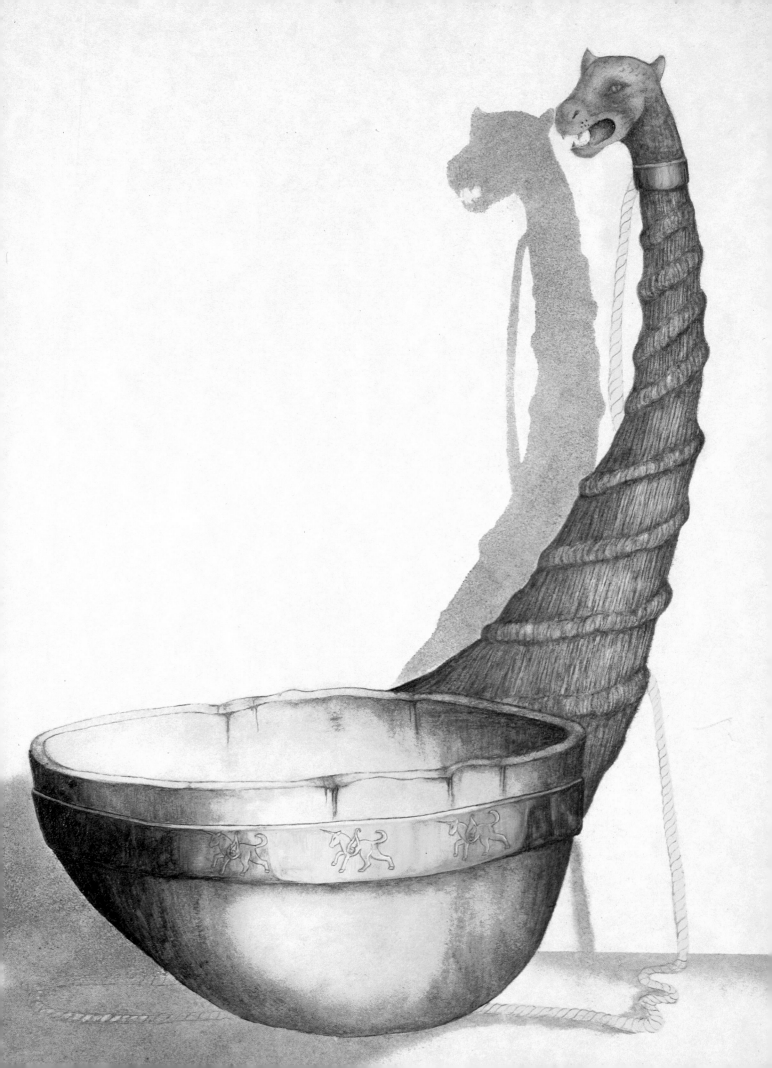

As Christianity spread across the West, so too did knowledge of the Unicorn, and it was soon seen and used as a symbol of Christ. The Bible, however, did not have much to say about the nature, appearance and habits of the Unicorn. That was left to other sources and, most of all, to the *Physiologus Graecus*. This book became the pattern for all other Medieval bestiaries, and at one point there were nearly as many copies in existence as there were Bibles.

The origins of the *Physiologus* are obscure. It has at different times been attributed to Solomon, Aristotle, St John Chrysostom, St Ambrose and St Basil, Archbishop of Caesarea in the fourth century. It is most likely, however, that it was compiled by several different hands in about the third century in Alexandria and later added to wherever it went. Copies have survived in all the major Middle Eastern and European tongues, including Icelandic.

The book is an encyclopedia of all that was known about real and fabulous beasts. It was heavily laced with a Christian commentary on each creature with an interpretation of the lessons to be learned from it. In later versions the commentary was dropped and in this simpler form it became a pure bestiary. Each entry opened with the words, 'The Physiologus [or Naturalist] says' which set the scene for the common belief that it had a single author. Details vary in different versions, but this is a typical extract:

◄ *Garden of Delights*

'There is a beast called the Unicorn which is extremely gentle, but hunters are unable to capture it because of its great strength. In size it is like to a young he-goat, with a single sharp horn in the middle of its brow. This is the ruse by which the huntsmen take it; they lead forth a young virgin, pure and chaste, and seat her under a tree. When the animal sees her, he throws himself in her lap and lays his head on her breast and falls into a dream. Then the maiden quietly reaches forth her hand and grasps the horn on his brow, and by this she and the huntsmen lead him to the palace of the king. Likewise the Lord Christ has raised up for us a horn of salvation in the midst of Jerusalem, in the house of his servant David, by the intercession of the Mother of God, a virgin pure, chaste, full of mercy, immaculate, inviolate.'

Early texts speak only of the Unicorn being led to the palace. The notion of killing it only starts being mentioned around the turn of the millenium. This was the same time that the story of Unicorns purifying springs for other beasts began to be included in Western manuscripts. The Unicorn is not always described as small in the *Physiologus* but it appears so often that it is probably the description of the original authors. However, what their source was is anyone's guess as, at that period, Alexandria was a complete melting pot of different cultures.

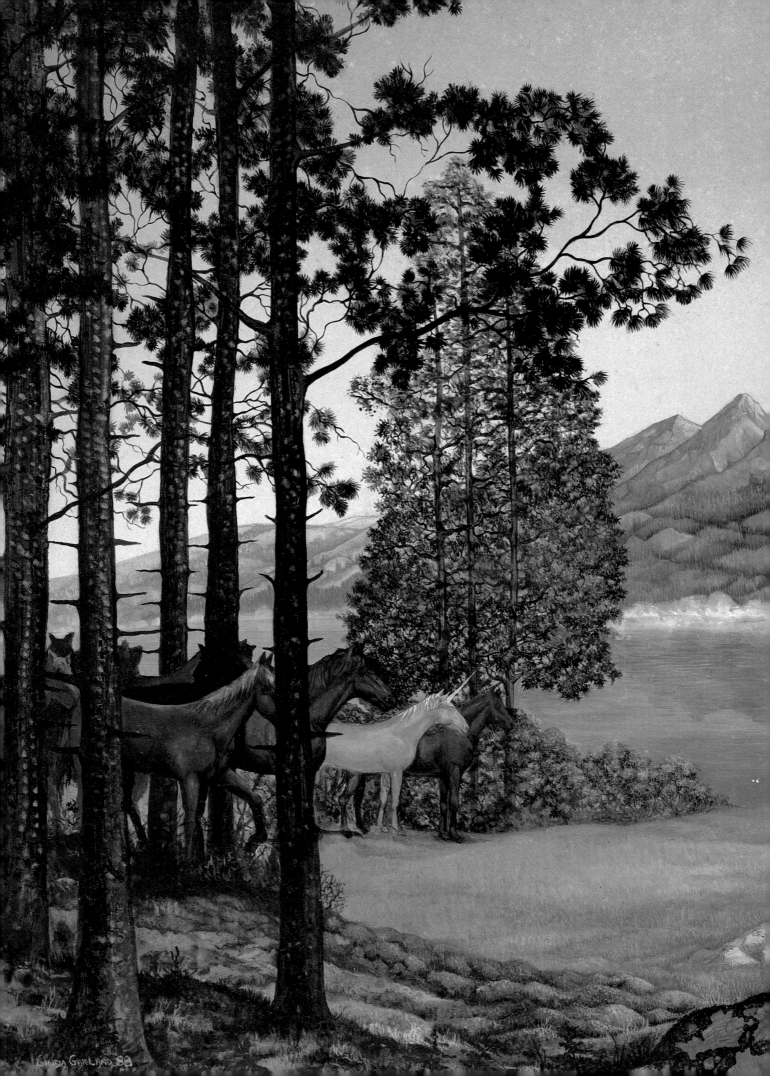

Unicorns in the Harz Mountains

he German-speaking peoples have always been especially fascinated by Unicorns. During the Middle Ages their churches and palaces were filled with graceful images of the beast, known to them as Einhorn. The Harz Mountains of central Germany have long been considered a haunt of the creature and there is still a cave there today called the Einhornhohle. It acquired its name in this way: Long ago, when much of Germany was still covered with dark, unmapped forests ruled by the old gods, an old wise woman lived in the Steingrotte Cave near Scharzfeld.

People came to her from all over the Harz region for advice and healing. This infuriated the Christian missionaries who denounced her as a witch. They used their influence over a Frankish king, whom they had converted, to send a party of soldiers and a monk to arrest her.

As they sweated up the hill to her cave the lady came out and looked down on them with such disdain that for a moment they faltered. But then they said to each other, 'She is only an old woman, what can she do against so many of us?' So they pressed on up the slope but faltered again when a pale Unicorn stepped out of the forest, its horn shining against the gloom under the trees. The creature went up to the wise woman and knelt before her. Then she mounted on its back and rode away.

The monk and the soldiers sprinted after her but the soldiers soon fell behind, cursing their heavy armour and weapons. Finally the monk caught up, but as he tried to lay hands on the woman she raised her arms to make signs in the air and he just disappeared. When the soldiers arrived at the place they found only a hole in the ground, at the bottom of which the monk lay, shattered and lifeless. There they buried him and gave the cave the name by which it has been known ever since.

Centuries later, in 1663, great excitement, hysteria even, was prompted by the discovery of a large Unicorn skeleton.

◄ *The Harz Mountains*

It was found among piles of other fossil bones in a limestone cave near Quedlinburg, a little north of the Harz Mountains. Crowds flocked to the site and many helped themselves to souvenirs in the initial confusion over who owned the cave. After a fierce legal battle, the Abbess of Quedlinburg took charge. However, despite her supervision, the skeleton was damaged during the excavations and emerged as a rather sorry and fragmented pile of bones. Scientific examination was to be undertaken by the famous scientist, Otto von Guericke, still noted for his experiment with the Magdeburg hemispheres.

Not too surprisingly, the skeleton that emerged from his reconstruction presents a very strange picture in the drawings of the time. It lacked half its spine, and appeared to be completely devoid of hindquarters.

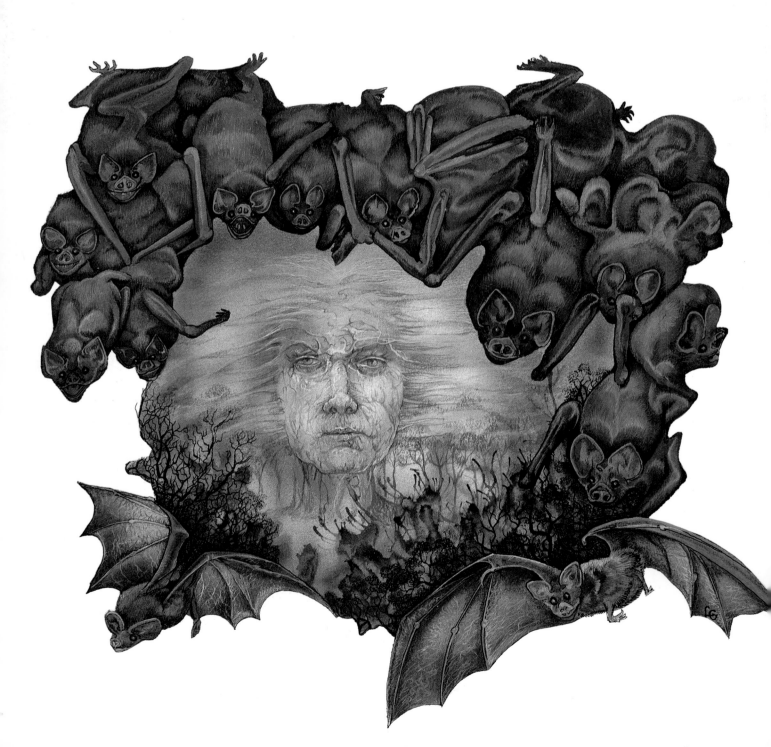

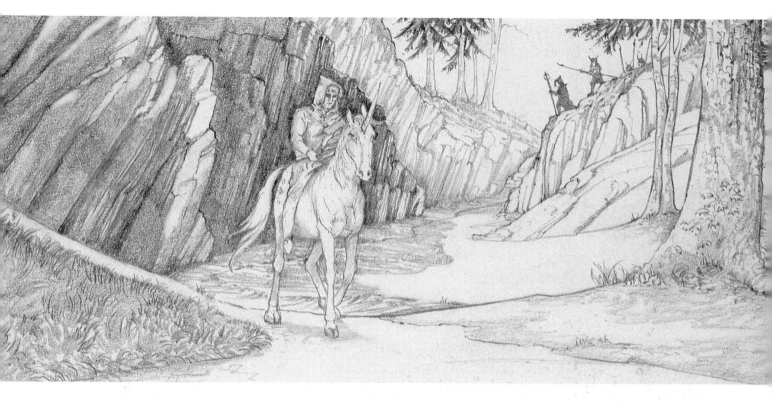

▲ *Pursuit*

However, its most interesting feature, the skull, had miraculously survived intact, and firmly attached to it was a single, straight, tapering horn some seven feet in length.

Quedlinburg is part of the ancient Hercynian Forest, and bones from there were for a long time sold as 'Hercynian Fossil Unicorn'. So one does not have to be too much of a fantasist to suggest that perhaps proof had at last been found of Caesar's 'ox shaped like a stag with a single horn'. However, the proportions of the skull and bones indicate that the beast must have been about the same size as the Biblical Re'em.

About a hundred years later, a similar skeleton was unearthed in the Einhornloch at nearby Scharzfeld, and both were examined by the philosopher and scientist Leibniz. He declared that these bones had completely converted him to a belief in Unicorns, whose existence he had previously doubted.

The region's link with Unicorns still continues to the present day. In an interview with *Die Ganze Woch* magazine in December 1991, the renowned Austrian naturalist Antal Festetics, visiting professor at Gottingen University, made a startling claim. While filming a wildlife documentary in the Harz Mountains, he had, he said, been out on horseback one night with a video camera, in the neighbourhood of the Einhornhohle when,

◄ *Wise woman of Scharzfeld*

'Suddenly a Unicorn came towards me at a gallop. There was a glow of light around the animal. My horse reared and almost threw me. Then, just as quickly, it was gone.'

The claim was repeated in a television interview the following April. What is more, Festetics claims to have captured the encounter on video. The footage is on hand in Gottingen for sceptics to view, though none of it was broadcast in his three-part programme.

How serious the claim was is open to question. Festetics has neither staked his reputation on it nor yet admitted to having exercised poetic licence. Whatever the truth, one can hardly imagine a more likely place to find a Unicorn in this day and age. The forest is dominated by the Brocken Mountain, which was associated with witches' sabbats in the Middle Ages. These, in turn, are usually the sign of an earlier link with cults of the Moon Goddess, whose creature is the Unicorn.

The region also straddles the old East–West German border. For forty-odd years after the Second World War a wide tract of it was fenced off as no-man's land and left entirely to its own devices. It was this part of the region that was the subject of Festetics' documentary. It is one of the last true wildernesses left in Europe, a slice of the dark enchanted wood of German folklore and legend, and one of the last possible refuges for creatures such as Unicorns that are unable to tolerate close proximity to humans.

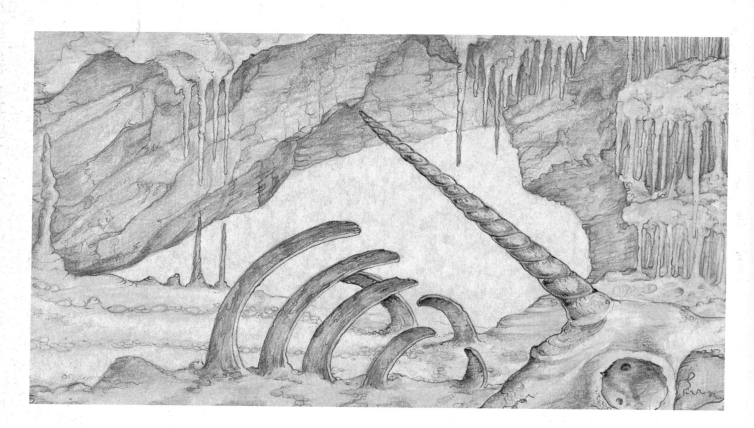

▲ *The Quedlinburg Unicorn*

Hercynian Mysteries ▶

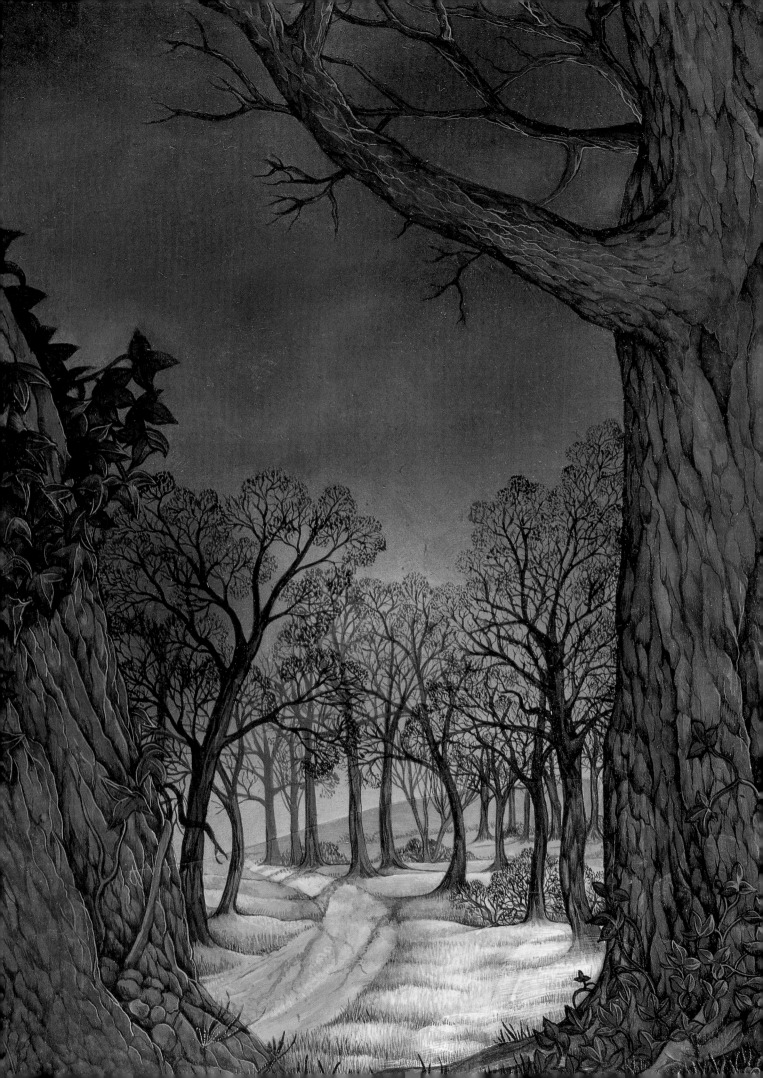

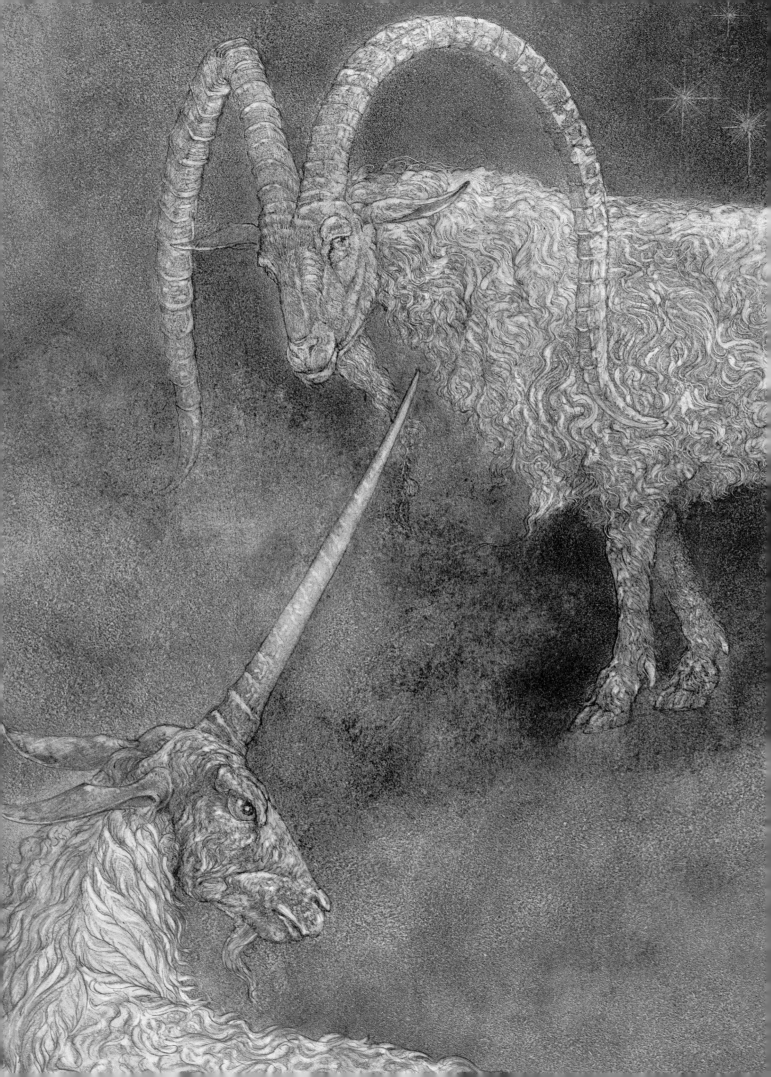

Alexander the Great

In the third year of the reign of King Belshazzar the prophet Daniel had a vision in which he was transported to the palace at Susa. There, by the river Ulai, he saw a great ram with two horns which pushed so mightily 'westward and northward and southward that no beasts might stand before him, neither was there any that could deliver out of his hand; but he did according to his will and became great.'

Then from out of the west, its feet not touching the ground, came a he-goat with a single mighty horn between its eyes which charged the ram 'in the fury of its power. And I saw him come close unto the ram, and he was moved with choler against him and smote the ram and brake his two horns: and there was no power in the ram to stand before him, but he cast him down to the ground and stamped upon him.'

The he-goat then became invincible and when his power was greatest the horn broke and four others sprang out, pointing to the four quarters of the earth; and the rule of the creature extended even to the hosts and stars of heaven, some of which it also cast down and trampled upon.

Following this vision the angel Gabriel appeared to Daniel in the likeness of a man and explained that the ram's two horns stood for the kings of Media and Persia who in partnership ruled most of the world known to the prophet. The goat's single horn was the Greek king who would overthrow them and the four horns which replaced it were the four kings who would succeed him and divide up the Persian empire between them.

The goat of Daniel's vision is the only real mention of a Unicorn in The Bible and unquestionably represents Alexander the Great, whose brief and astonishing career perfectly matches this poetic description. The choice of symbol is singularly apt and Alexander has been linked by legend with Unicorns of various kinds ever since.

By a strange coincidence he is also linked with our earliest European account of the Unicorn. The writings of Ctesias were known to Alexander and almost certainly played a part in firing his ambition to explore and conquer Asia, which at that time was believed by the Greeks to end at the Himalayas. His private tutor, the renowned Aristotle, knew Ctesias well and although he believed him gullible and prone to exaggeration, Aristotle expresses no doubt about the existence of Unicorns. He even exercised his own mind on the subject briefly and in a way that suggests he had access to other sources of information.

According to legend, Alexander first encountered a Unicorn when he was about thirteen years old and one was presented for sale to his father Philip, king of Macedonia, by a Thessalian named

◀ *Daniel's vision*

Philonicus. Called Bucephalus on account of its horn (the name meaning literally, if not very poetically, Ox-head), the beast lashed out so furiously at every attempt to mount it that soon Philip's champion riders gave up and it was led away as wholly useless and intractable.

Alexander protested that they were missing a wonderful opportunity, for want of the skill and courage, to manage the creature properly. At first Philip ignored him but, when he persisted, the king finally said a little angrily, 'Do you think you know so much better than all these grown champions?'

'I could manage this creature better than they have done,' Alexander said stubbornly.

Now Philip had not made the attempt himself because of a leg injury but he took his son's defiance personally and thought maybe it was time to teach him a lesson in humility, 'And if you fail,' he said, 'what will you forfeit for your rashness?'

'The whole price of the beast,' Alexander replied.

'Do you have thirteen talents?' the king asked, that being the Thessalian's asking price.

'No, but I will get it.'

'Very well, and if you succeed in taming Bucephalus you can have him as a gift.'

Laughter spread through the assembly with news of this wager and there was much debate over whether Alexander was wonderfully brave or simply mad. Many side bets were exchanged as Bucephalus was led on to the field, and not a few of them were on whether the boy would survive his wager, let alone win it.

Trumpets brayed for silence as Alexander strode confidently out on to the field. Small for his age, he looked a child beside the large Unicorn, but his confidence was not just bravado. He had taken notice of several ways in which, it seemed to him, previous attempts to tame the beast were misguided. Their biggest mistake was approaching Bucephalus as a horse whose will needed to be broken. In contrast, Alexander recognized that the Unicorn could only be ridden with its own consent. They had also thrown their cloaks over the creature's head before trying to mount it. So to prove he had no intention of doing this, Alexander unfastened his cloak and dropped it on the ground. He also made it obvious to Bucephalus that he carried no weapon, whip or rope on his person.

Another thing Alexander had noticed was that Bucephalus seemed nervous of the long shadows being cast by those around him. So when he took the bridle Alexander dismissed the handlers and turned so the low sun was directly in the Unicorn's eyes. Then, bowing from the waist, he said, 'Greetings noble beast. I come in friendship. Only permit me to ride on your back today and you may choose your freedom.'

Thus he remained, totally defenceless. The Unicorn stepped closer and lowered its head so the gleaming horn almost touched the skin over the boy's heart. There was a shifting in the crowd and a drawing of strings by those bowmen posted by Philip to protect his son, but all knew that should the beast strike, nothing could save Alexander.

After what seemed a long while,

Alexander and Bucephalus ▶
Demonic Unicorns (next page)

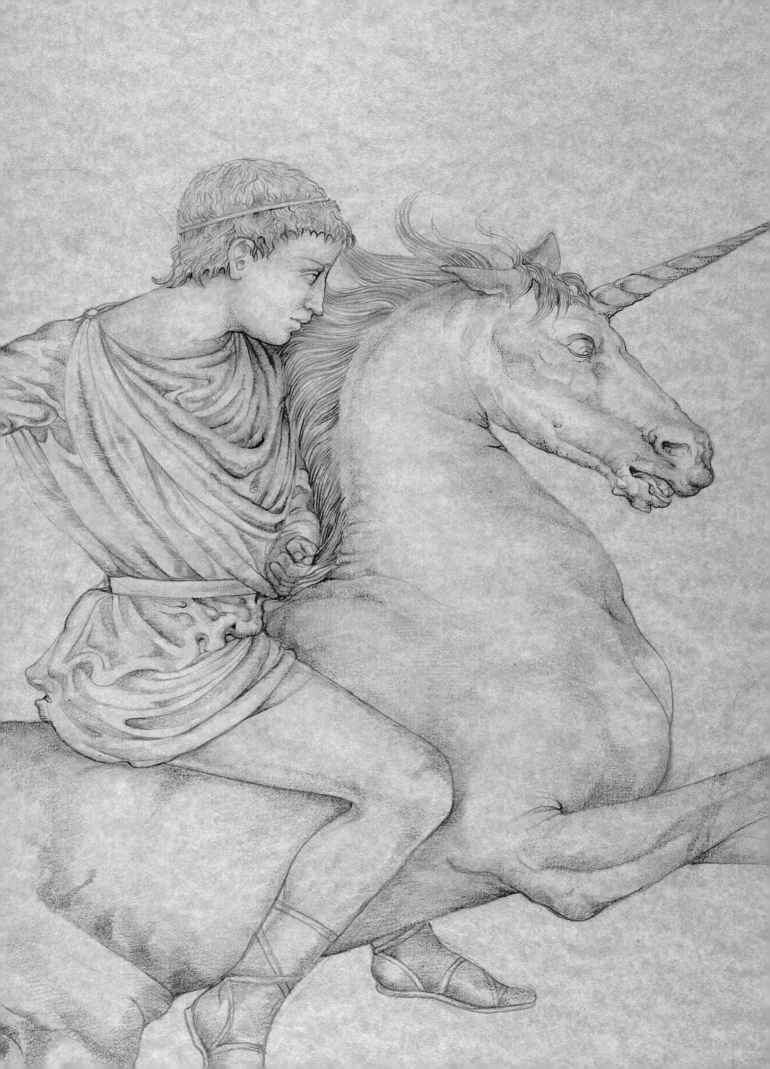

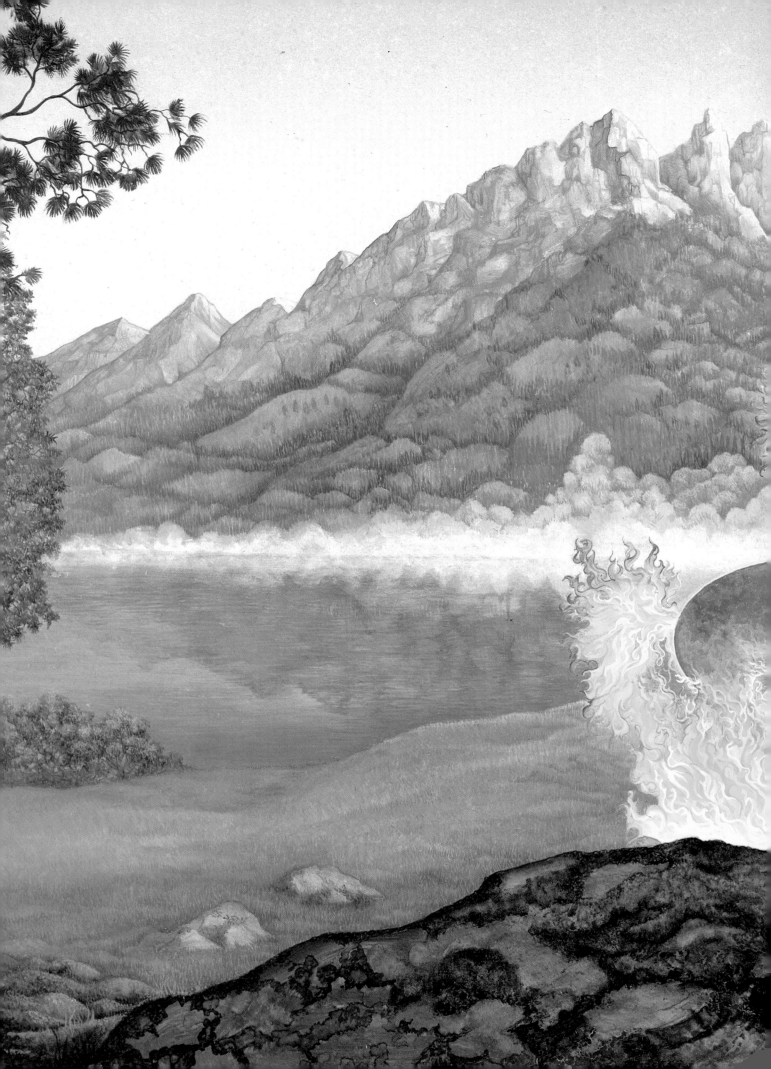

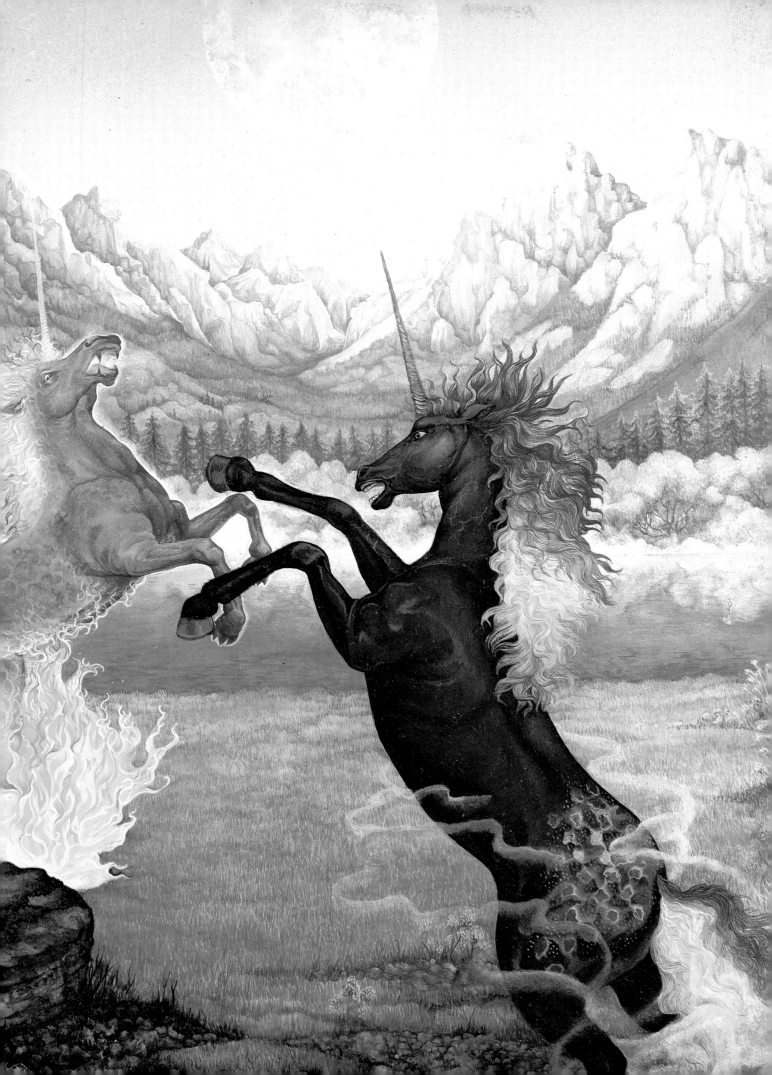

Bucephalus suddenly lowered the point of his horn to the ground and, trembling, allowed the youth to spring on to his back. Once there, Alexander sat still for a while as they accustomed themselves to each other. Then Bucephalus leapt forward in a gallop that carried them away into the distance swifter, it seemed, than the wind. Many in the crowd feared never to see their impetuous prince again, but at last he turned in the distance and came riding back to cheers and rejoicing. The king, it is said, shed tears of joy and pride and, kissing the boy as he climbed down from the beast, cried, 'Oh my son, look out for a kingdom equal and worthy of you, for Macedonia is too small to contain you.'

Bucephalus remained with Alexander almost to the end of both their lives and was ridden by him into every major battle in his conquest of Egypt and the Persian Empire. Something of the Unicorn's temperament seems to have rubbed off on Alexander too. The young hero became famous for his fairness, restraint and clemency towards enemies who submitted to him.

In fact, the story of Bucephalus' capture during an expedition near the Caspian Sea is a perfect example of Alexander's noble behaviour. As he was in the habit of only riding the Unicorn when going into battle, Bucephalus was usually transported in style in a cage designed to prevent reckless soldiers from trying their luck in riding him. On this occasion, while Alexander was off exploring with the majority of his army, some raiders from the northern steppes carried off Bucephalus and his escort as prisoners. Alexander was so incensed that he sent word that if they were not returned, every man, woman and child of that nation would be put to the sword. The raiders, who had now seen the enormous size and might of the returning army, realized this was not an empty threat. They returned Bucephalus and his guards immediately, and also surrendered all their cities into Alexander's hands. Alexander's noble response was to treat them with all kindness and even to pay a ransom for Bucephalus.

Alexander also had connections with other Unicorns. One such beast, notable for the gem at the base of its horn, was presented to him on his travels by Queen Candace. There are also numerous Eastern accounts of him hunting the fierce

Karkadann, usually shown as a one-horned ox or rhinoceros. On occasion he also had to do battle with demonic Unicorns that were the manifestations of hostile spirits. With all these Unicornic associations it is ironic that Alexander should have survived all his battles only to succumb to poison at the tender age of thirty-two, but by then Bucephalus was no longer with him.

Legend and history agree that Bucephalus died in Alexander's last great battle with King Porus of India on the banks of the Jhelum or Hydaspes, one of the five great branches of the Indus River. Only the cause of his death is disputed, whether it was from wounds, age or simple exhaustion. Whichever it was, his demise marked a change in Alexander's fortunes. His legendary luck seemed to desert him and his character, which had begun to show signs of instability, took a rapid turn for the worse.

Alexander won the battle against Porus, but only just. It was his last great victory and after it his army refused to go any further. He was forced to turn back, but his decision to explore the coast on the way led to thousands of his troops perishing as they crossed the Makran desert in what is now southern Pakistan. Plutarch puts the number at 80,000 men and, although Alexander faced all hardships on equal terms with his men, the death toll did much to undermine support for him.

Back in the heart of the Persian Empire he set about restoring order. He employed some of his old magnanimity, but it was tempered by a good deal of new harshness which shocked many Greeks and Macedonians. Then, tiring of administration, he began organizing an expedition to circle Africa round to the gates of the Mediterranean. It was at this point he caught a fever which hardly seemed serious at first, but after ten days of steady deterioration he died.

After all he had risked it was an ignoble death, and rumours of poisoning soon began circulating, with the finger even being pointed at Aristotle as one of the instigators. Alexander's mother had many suspects put to death, but the full truth of the matter was never disclosed. And, sad to say, not that many people wanted to know. For all his astonishing achievements it came as a relief to most of his generals and followers when Alexander died. It meant they could settle down to enjoy the fruits of their labours and carve up his empire just as described in Daniel's vision.

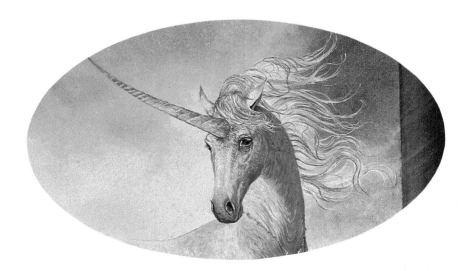

Travellers' Tales

That Alexander's luck should desert him after his Unicorn's death would not have been seen as pure coincidence at the time. Bucephalus' death was probably even seen as having saved India from conquest. A millenium and a half later it was saved by a Unicorn again when, at the start of the thirteenth century, Genghis Khan set out with a vast army to invade Hindustan.

In a pass high on Mount Djadanaring in the north of that country, from where it could be seen laid out below like an open jewel-case, a Unicorn suddenly appeared before the conqueror. Genghis Khan stopped and the multitudes of his followers rumbled to a halt behind him. Then the beast approached the commander and knelt before him humbly three times before disappearing back to the heights. Genghis Khan was thrown into a trance, after which he mused aloud: 'What does it mean that this speechless wild animal bows before me like a human? Is the spirit of my father sending me a warning from Heaven?' In the end he decided that was exactly what the omen did mean, so he turned his army around and marched away.

Unicorns were reputedly common in the mountainous regions of India and it is thought this almost certainly meant Tibet. The other famous haunt of Unicorns from

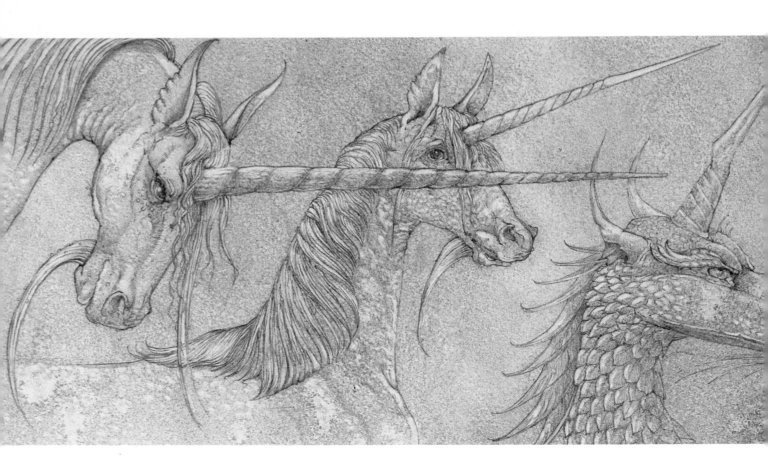

early times was Ethiopia. The fabled home of Prester John, Ethiopia was, until recently, the most ancient Christian realm in the world, with an emperor whose descent could be traced back to the Queen of Sheba.

One of the earliest surviving reports of a sighting in Ethiopia comes from Cosmas Indicopleustes. He was an Alexandrian merchant who spent many years travelling India and the Middle East before becoming a monk and settling down to write his memoirs, *Christian Topography*, in about 550 AD. Of Ethiopia he writes: 'Although I have not seen the Unicorn, I have seen four brazen statues of him in the four-towered palace of the King of Ethiopia, and from these I have been able to draw a picture of him as you see. People say that he is a terrible beast and quite invincible, and that all his strength lies in his horn. When he finds himself pursued by many hunters and about to be taken he springs to the top of some precipice and throws himself over it, and in the descent he turns a somersault so that the horn sustains all the shock of the fall and he escapes unhurt.' Cosmas' drawing shows a spirited, antelope-like beast with a horn almost as tall as itself jutting from the forehead.

Some 1,000 years later Marmol Caravaial wrote in his *General Description of Africa*: 'Among the Mountains of the Moon in High Ethiopia there is found a beast called the Unicorn which is as large as a colt of two years and of the same general shape as one. Its colour is ashen and it has a mane and a large beard like that of a he-goat. On its brow it has a smooth white horn the colour of ivory, two cubits long and adorned with

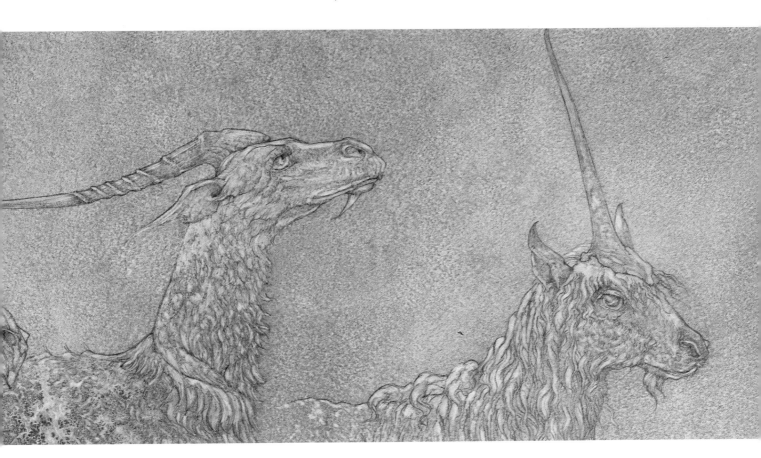

▲ *Many varieties of Unicorns have been reported through the ages*

handsome grooves that run from base to point. This horn is used against poison, and people say that the other animals wait until this one comes and dips its horn in the water before they drink. It is such a clever beast and so swift that there is no way of killing it.'

In 1503 Lewes Vertomannus of Rome wrote in an account of his voyages of a visit to the Temple of Mecca: 'On the other part of the temple are parks or places enclosed where are seen two Unicorns, named of the Greeks monocerotae, and these are showed to the people for a miracle, and not without good reason for their seldomness and strange nature. The one of them, which is much higher than the other, yet not much unlike to a colt of thirty months of age; in the forehead groweth only one horn in a manner right foorth of the length of three cubits. The other is much younger, of the age of one year and like a young colt; the horn of this is of the length of four handfulls.

'This beast is of the colour of a horse of weesell colour and hath the head like a hart, but no long neck, a thynne mane hanging only on the one side. Their legs are thin and slender like a fawn or hind. The hoofs of the fore-feet are divided in two, much like the feet of a goat. The outer part of the hinder feet is very full of hair. This beast doubtless seemeth wild and fierce yet tempereth that fierceness with a certain comeliness.

'These Unicorns one gave to the Sultan of Mecca as a most precious and rare gift. They were sent him out of Ethiopia by a

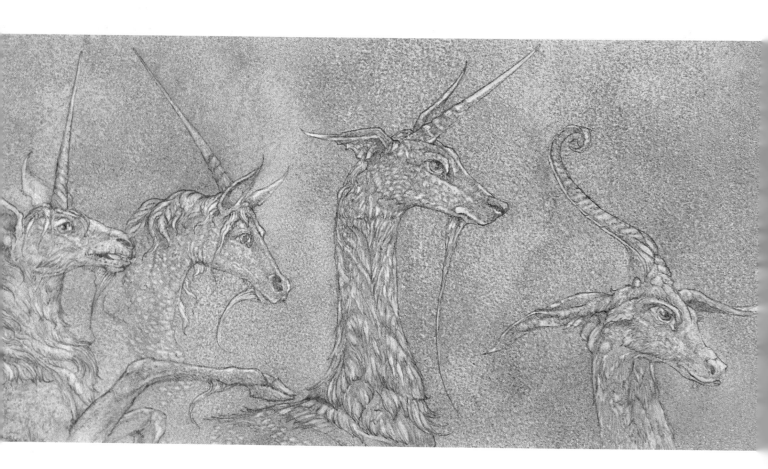

king of that country who desired by that present to gratify the Sultan.'

Later, while sailing to Persia, Vertomannus was driven back to the African coast by contrary winds. In the bustling port of Zeila: 'I saw there also certain kine having only one horn in the middle of the forehead, as hath the Unicorn, but the horn bendeth backwards.'

Vincent Le Blanc declares in his *Famous Voyages* of the late sixteenth century: 'I have seen a Unicorn in the seraglio of the Sultan, others in India, and still others at the Escurial. That there are some persons who doubt whether this animal is to be found anywhere in the world I am well aware, but in addition to my own observation there are several serious writers who bear witness to its existence, Vertomannus among others.'

Father Hieronymus Lobo, a Portuguese Jesuit missionary who lived about ten years in Ethiopia up to 1632, wrote in an account published by Samuel Johnson: 'In the province of Agaus has been seen the Unicorn; that beast so much talked of and so little known. The prodigious swiftness with which the creature runs from one wood into another has given me no opportunity of examining it particularly; yet I have had so near a sight of it as to be able to give some description of it.

'The shape is the same as that of a beautiful horse, exact and nicely proportioned; of a bay colour, with a black tail, which in some provinces is long, in others very short; some have long manes hanging to the ground. They are so timorous that they never feed but surrounded with other beasts that defend them.'

Of the numerous similar accounts of the Ethiopian Unicorn it is perhaps worth considering one more quoted by Thomas Bartholinus, Professor of Anatomy in Copenhagen, in his monumental work *De Unicornu Observationes Novae* published in Amsterdam in 1678. This was unusual in being the testimony of an Ethiopian, an ambassador to the court in Copenhagen travelling under the magnificent name of Franciscus Marchio de Magellanes. On arrival in 1632 he was very taken with an Alicorn in the royal museum because, he said, it was so unlike the horn of the Unicorn familiar to him in his own country. That horn was often no more than three spans in length and although it had a grain running from base to point, this was straight and not spiral. Moreover, from the tip of the horn sprouts a tuft of hair, reddish and the size of a human fist. Other than that, his description is pretty much as given by Father Lobo and the others. The horn was said to be golden and hollow at the root and famous for its power against poison when applied either internally or externally. Its bearer was known to Africans as the Tiray Bina and was about the size and shape of a small horse, very fast and wild and an inhabitant of the desert.

All the most reliable reports of African Unicorns are somehow tied to Ethiopia. Sending Unicorns as gifts to other potentates seems to have been one of the favoured forms of diplomacy of Prester

John, the legendary Christian priest and king of Ethiopia. However, explorers elsewhere in the Dark Continent heard rumours of one-horned beasts among the Bantu, Hottentot and Bushmen. In fact, there were so many rumours that for a while in the nineteenth century many explorers, David Livingstone among them, were confidently expecting the riddle of the Unicorn to be imminently unravelled. Interest in the creature was compounded by Sir John Barrow's appraisal of thousands of cave paintings in South Africa. He came to the conclusion that many of them were deliberate representations of unicornic animals.

One does not have to believe in Unicorns to accept all the tales and rumours coming out of Africa. Visitors to North Africa today are quite likely to see a one-horned Oryx, and it will take a telephoto lens to reveal the stub of its second horn broken off in battle or a tangle with a tree. Apart from the fact that its horn slopes steeply backwards, a one-horned Oryx fits the description of a Unicorn quite well. It is quite possible that, even knowing the cause of the deformity, and given the mystique of horns among hunters, such creatures might still be regarded with a special awe. The assumption that such oddities are the sole source of the rumours, particularly in Ethiopia, is enormously cynical. Not all witnesses can have been completely gullible or unable to test with their own eyes if the horn sprouted from the centre or side of the forehead. Fortunately, as we shall soon see, it is almost certain that they were not.

One-Horned Oryx ▶

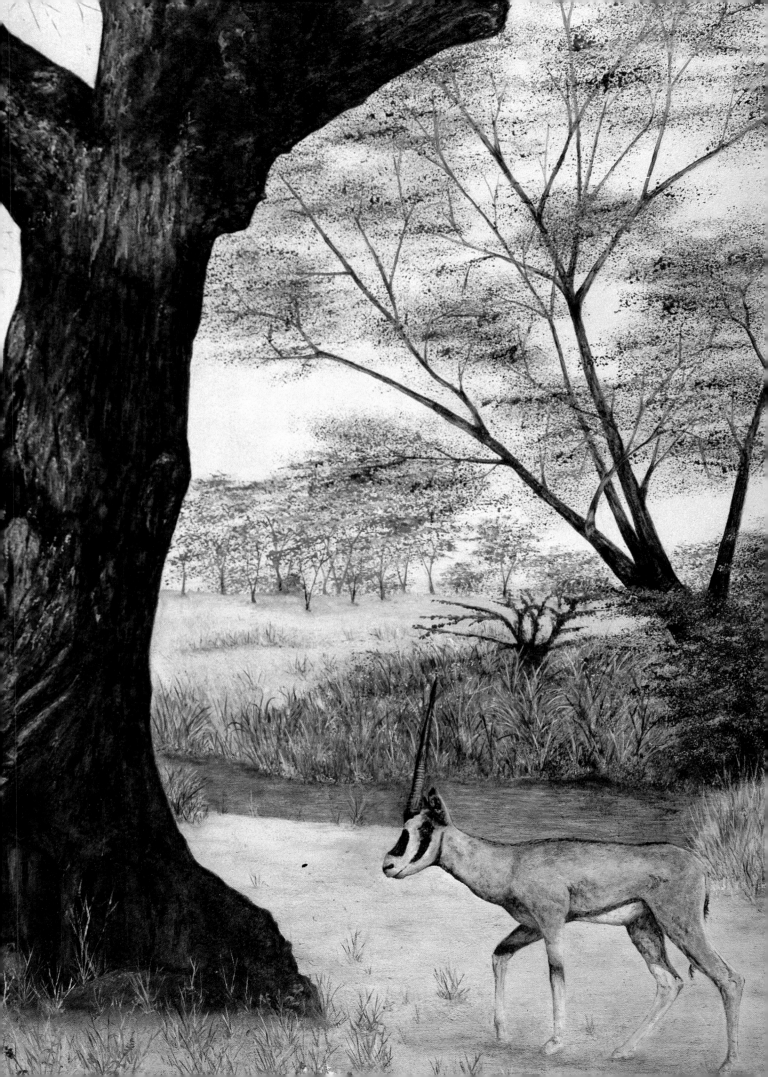

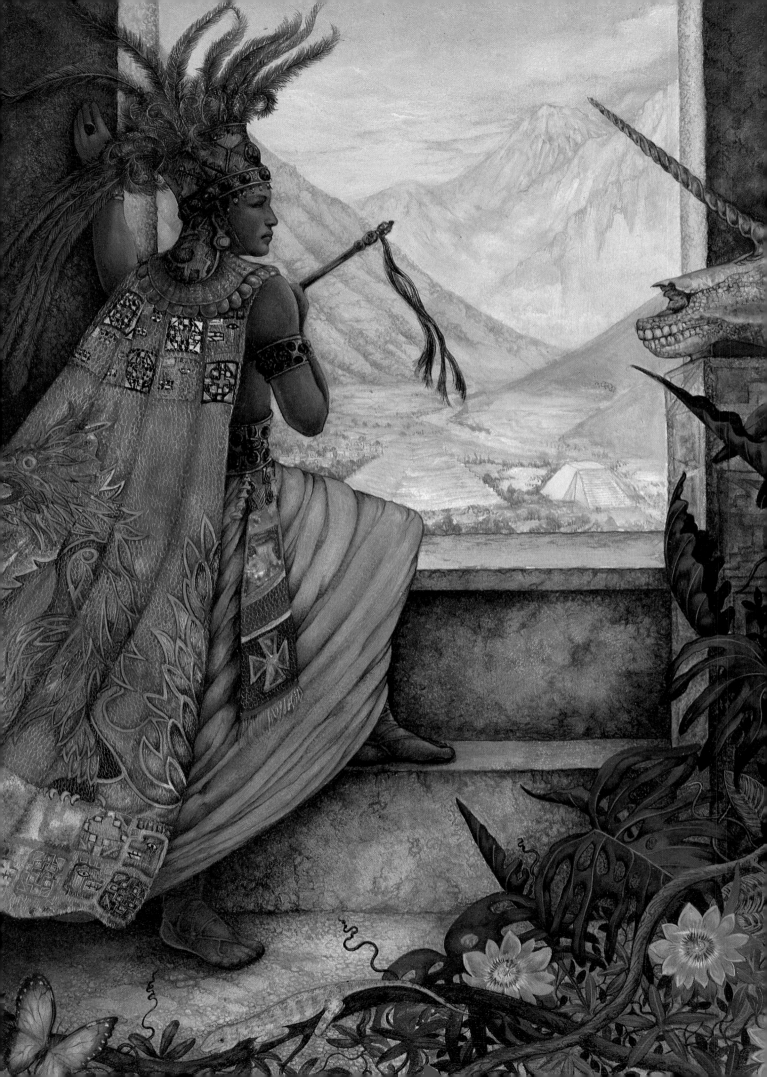

American Rumours

onsidering the popularity of Unicorns in the United States it is surprising there have not been more reported sightings and encounters. There have been some, though, beginning with the Spanish conquistadors, from whose journals we learn of one Friar Marcus of Nizza who set out from Mexico in 1539 to find the legendary Seven Cities of Cibola.

On arrival he was shown, among other wonders: 'A hide half as big again as that of an ox and told it was the skin of a beast which had but one horn upon its forehead, bending towards its breast, and that out of the same goeth a point forward with which he breaks any thing that he runs against.'

In the journal of his voyage of 1564, Sir John Hawkins writes of Florida: 'The Floridians have pieces of Unicorns' horns, which they call Souanamma, which they wear about their necks, whereof the Frenchmen obtained many pieces. Of those Unicorns they have many; for they affirm a beast with one horn which, coming to the river to drink, puts the same in the water before he drinks. Of this Unicorn's horn there are some of our company that, having got them of the Frenchmen, brought them home to show.'

The most famous early account though is that of Dr Olfert Dapper in *Die Unbekante Neue Welt*, published in Amsterdam in 1673, who writes: 'On the Canadian border there are sometimes seen animals resembling horses but with cloven hooves, rough manes, a long straight horn upon the forehead, a curled tail like that of the wild boar, black eyes and a neck like that of the stag. They live in the loneliest wildernesses and are so shy that the males do not even pasture with the females except in the season of rut, when they are not so wild.'

◄ *Floridian Indians*

Doctor Dove's Unicorn Bull

uring the nineteenth century it was still widely believed in the West that the Unicorn was a real creature, or at least had been in the not too distant past. Griffins, giants, dragons and basilisks had long been banished to the realms of myth and fantasy, but at the century's close it was still possible for respected scholars to argue in favour of the Unicorn's existence, even enlisting Darwinian theory in support, without being totally ridiculed.

However, the believers were swimming against a growing tide of scepticism emanating from the scientific community. So when, in *Alice Through the Looking Glass*, Alice met a Unicorn taking a break from his great battle with the Lion, the result was mutual astonishment. The Unicorn recovered first.

'What...is...this?' he said at last.

'This is a child,' he was told. 'We only found it today. It's as large as life, and twice as natural.'

'I always thought they were fabulous monsters,' said the Unicorn. 'Is it alive?'

'It can talk,' he was assured solemnly.

The Unicorn looked dreamily at Alice, and said 'Talk, child.'

Alice could not help her lips curling up into a smile as she began, 'Do you know, I always thought Unicorns were fabulous monsters, too? I never saw one alive before.'

'Well, now that we have seen each other,' said the Unicorn, 'if you'll believe in me, I'll believe in you. Is that a bargain?'

The person credited with starting the rot was the French naturalist Baron Georges Leopold Cuvier, enormously respected for his pioneering work on dinosaur fossils. In a commentary on Pliny's *Natural History* he pronounced that in his opinion a cloven-hooved ruminant, such as the Unicorn was supposed to be, could not possibly have a single horn because it would have to grow over a division of the bone of its forehead.

This theory had previously been advanced by some German scholars without great effect, but such was the strength of Cuvier's reputation that for many scientists it seemed like the last word on the subject. The debate over the existence of Unicorns was over and done with for many people, yet reports continued to come in from the Far East and Africa. This suggested that while Cuvier may well have spoken an apparent truth, the possibility of other variations still existed. In Europe itself the occasional surfacing of Unicorn rams has been reliably reported since the fifth century BC when the head of one was brought to Pericles, ruler of Athens, from one of his estates. As an omen it was interpreted as signalling, correctly as it happens, his imminent victory over a bitter political rival. The association possibly arose in part because Pericles himself suffered from a curious

'If you'll believe in me, I'll believe in you,' ▶

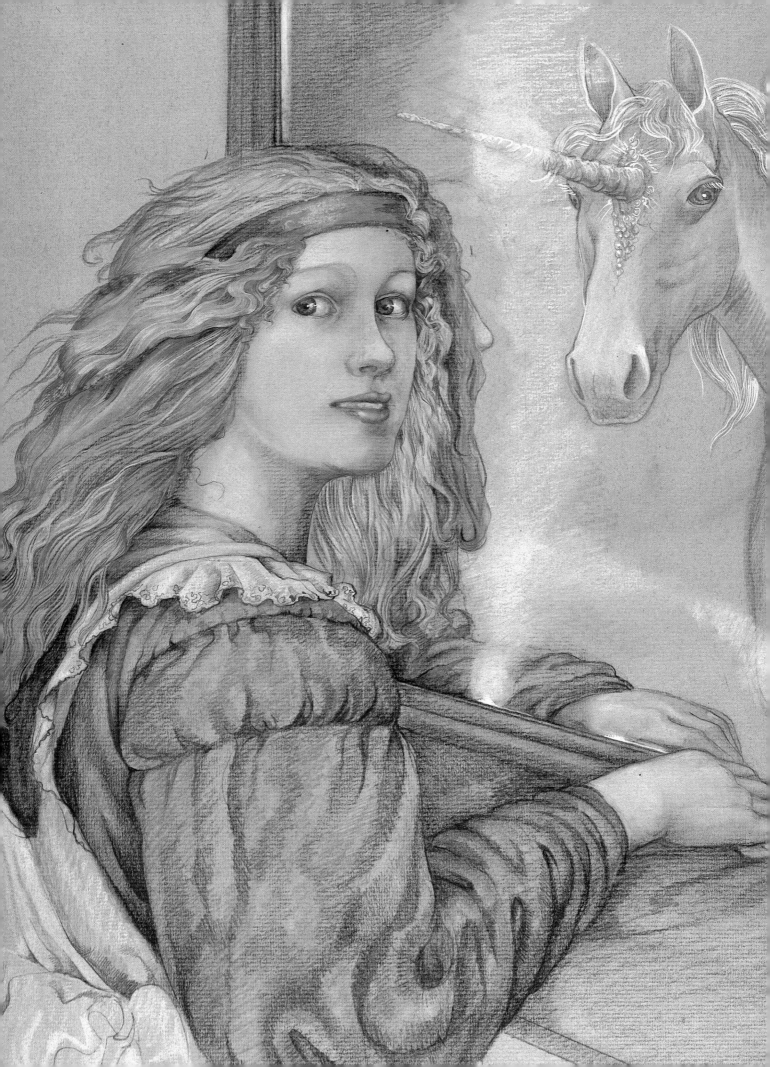

backward elongation of the skull which led most sculptors to portray him wearing a helmet.

Such sports of nature still continue to appear from time to time in the media today. They might all be dismissed as hoaxes were it not for the well-documented gift of several one-horned sheep from Nepal to the Prince of Wales which were exhibited at the London Zoological Gardens in 1906. These animals were almost certainly not just the result of nature playing games. According to the British Resident of the time at the Nepalese Court: 'There is no special breed of one-horned sheep in Nepal, nor are the specimens which have been brought here for sale freaks. By certain maltreatment ordinary two-horned sheep are converted.... I am told that the object of producing these curiosities is to obtain fancy prices for them from the wealthy people of Nepal.'

Rumours of similar practices have also emanated from Africa which, while they tell us nothing about the wild Unicorns of Ethiopia, may well explain how the king of that country was able to present so many tame ones to fellow potentates.

Such rumours and possibilities were known to Dr W. Franklin Dove of Maine University who also spotted a flaw in Cuvier's reasoning. Cuvier, it seems, had assumed that horns grew out of the skull, whereas they actually start as unattached bits of tissue which later root themselves in it. The positioning of horns is quite open to natural or artificial variation, so Unicorns,

Dove reasoned, were not a total contradiction of the laws of nature.

To test this, in 1933 he took a day-old Ayrshire calf, surgically removed its horn buds, trimmed them to fit together and replanted them in the centre of its forehead. As the young bull grew, the buds fused and produced a single solid, straight and pointed horn a foot or so in length which proved equally useful for fighting and uprooting fences, far superior in fact to the usual brace of curved ones.

Dr Dove's Unicorn bull became the leader of its herd and was very rarely challenged by other males. When bulls charge each other the main aim is to crack skulls until one or other can take no more. Charging towards an enemy who has a spike aimed right between your eyes is a different game altogether. So effective was the single horn that one almost wonders why evolution did not do Dr Dove's work for him.

An interesting side effect of the experiment was the nature of the bull's temperament. Being secure in his strength led him to become unusually gentle and mild mannered, echoing what has so often been said of the true Unicorn's nature.

CHAPTER 3

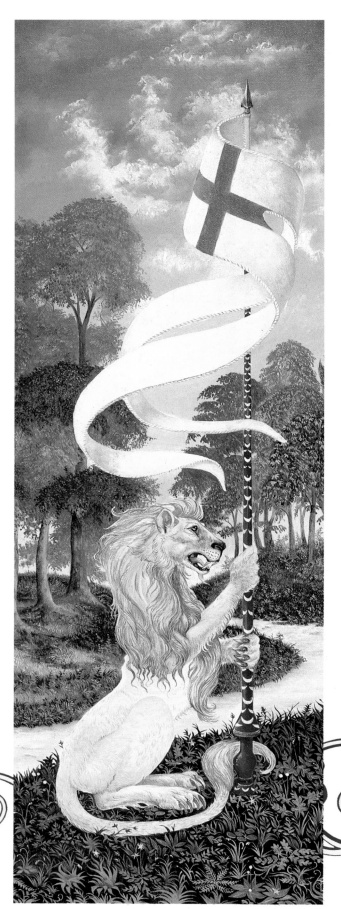

The & the

*The Lion and the
Unicorn
Were fighting for the
crown
The Lion beat the
Unicorn
All around the town*

Lion
Unicorn

Some gave them
white bread,
Some gave them brown,
Some gave them
plum cake
And drummed them
out of town.

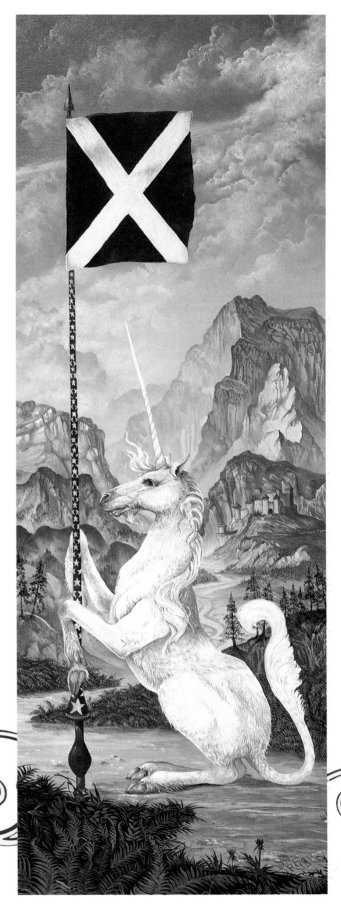

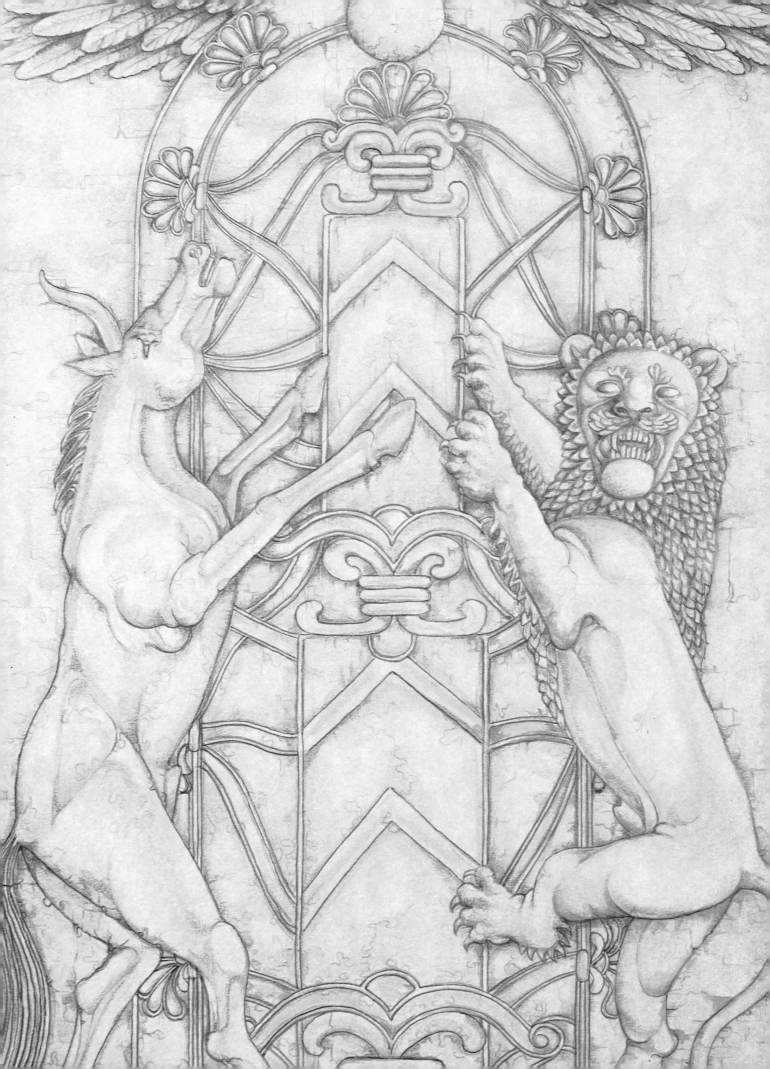

The Unicorn in this nursery rhyme is probably the most famous of all, but we are also familiar with the Unicorn in the British royal coat of arms. Through colonial adventure, the coat of arms found its way around the world and is recognized by millions of people even if they know nothing about its origins.

It dates from the early seventeenth century when James VI of Scotland became James I of England and united the Scottish and English crowns. The Union demanded a new royal coat of arms combining those of England, which were supported by two Lions, and Scotland, whose shield was carried by two Unicorns. The obvious compromise was one Lion and one Unicorn.

When and why Unicorns were adopted by Scotland remains shrouded in mystery. Nevertheless, by at least the time of Robert II or III in the late fourteenth century two Unicorns had been carved in the royal arms above the gateway of Rothsay Castle. They have remained supporters of the Scottish shield ever since. In the late fifteenth century some gold coins were minted by the Scottish crown, called the Unicorn and the half-Unicorn (worth eighteen and nine shillings, respectively), and they both bore an image of a Unicorn on one side.

The English shield had always been supported by at least one Lion but was often paired with a variety of other heraldic beasts, including an antelope, a bull, a boar, a dragon and, in the reigns of Mary and Elizabeth I, a greyhound. Pairing it with a Unicorn therefore caused no great upset on the English side. It was even welcomed as a particularly apt symbol of reconciliation between these ancient enemies, as the even more ancient rivalry between the Lion and the Unicorn was very widely known at the time. The nursery rhyme was almost certainly a response to the marriage of England and Scotland, and a folk reminder of its on-going complications, but the beasts were at war long before this.

From ancient Assyria come many ancient relief carvings in stone of the sacred World Tree whose roots go down to the Underworld and whose branches reach up to Heaven. In the background, often tangled in the branches, is a crescent moon and stars. On one side of the tree is a rampant Lion, on the other a Unicorn and they look as if they are about to engage in hostilities. It has been argued that the second beast is not a Unicorn but simply an antelope seen in profile. In many cases this is a valid comment, but the existence of bronze statuettes of one-horned ibex from second-century BC Persia does support the Unicorn theory.

In some examples, too, the beast's head is not shown in complete profile and still only displays one horn, confirming that it is a Unicorn. The most famous example of this in the West is probably the Horn of Ulph. This is one of the principal treasures of York Minster and lends its name to the valuable tracts of land called *Terrae Ulphi* which the See of York still holds. In its entry for the year 1006, Dugdale's *Monasticon* tells the tale thus: 'About this

◄ *Assyrian World Tree*

time Ulphe, the son of Thorald, who ruled west of Deira, by reason of the difference which was like to arise between his sons about the sharing of his lands and landships after his death, resolved to make them all alike; therefore, coming to York with that horn wherewith he used to drink, filled it with wine and before the altar of God and Saint Peter drank the wine, and by that ceremony enfeoffed this church with all his lands and revenues.'

Exactly where and when the horn was made is unknown. The carving of its ivory is fairly crude but the motifs are plainly of early Middle Eastern origin and the chances are that either it or the original on which it was based arrived in Deira via the great land trading route between Byzantium and Scandinavia. One of the designs shows the favourite Assyrian theme of a Lion sinking its teeth and claws into an antelope, attacking from behind. Elsewhere an unmistakable World Tree is being touched by the horn of an equally unmistakable, though rather bovine, Unicorn.

There is also a tale common throughout the ancient Middle East which brings together Lion, Unicorn and Tree in a way that suggests it is the myth on which such carvings were based. It tells of how at the dawn of time the Lion and Unicorn chased each other across the heavens. For fourteen

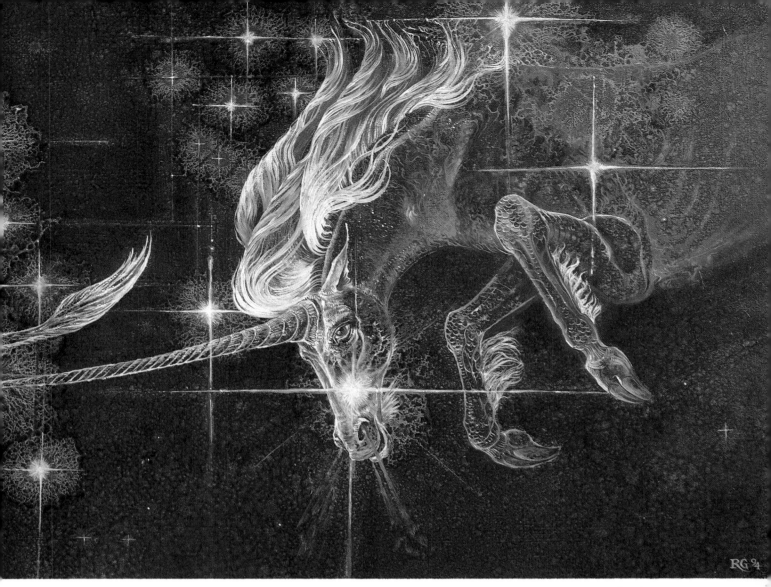

▲ *Heavenly chase*

years the Lion chased after the Unicorn through the stars, but it pulled away, circled round and for the next fourteen years it was the Unicorn who chased the Lion, slowly but steadily gaining, closing the distance between them with its horn growing ever more sharp and deadly. In despair the Lion came to earth and plunged into a forest with the Unicorn on its tail, its horn lowered for the kill. Suddenly an enormous tree stood in their path. The Lion raced straight towards it but at the last moment threw himself to one side. The Unicorn, seeing the danger too late, charged straight on and buried its horn to the hilt in the timber. While the Unicorn

was thus pinned, the Lion crept up from behind and devoured him.

Variations of this tale crop up in many different parts of the world and in many languages. Shakespeare mentions it in passing and as if taking for granted that his audience will recognize the reference, Edmund Spenser in *The Faerie Queene* writes:

> *Like as a Lion whose imperial power*
> *A proud rebellious Unicorn defies,*
> *T'avoid the rash assault and wrathful stour*
> *Of his fierce foe, him to a tree applies,*
> *And when him running in full course he spies,*
> *He slips aside; the whiles that furious beast*
> *His precious horn, sought of his enemies,*
> *Strikes in the stock, nor thence can be released,*
> *But to the mighty victor yields a*
> *bounteous feast.*

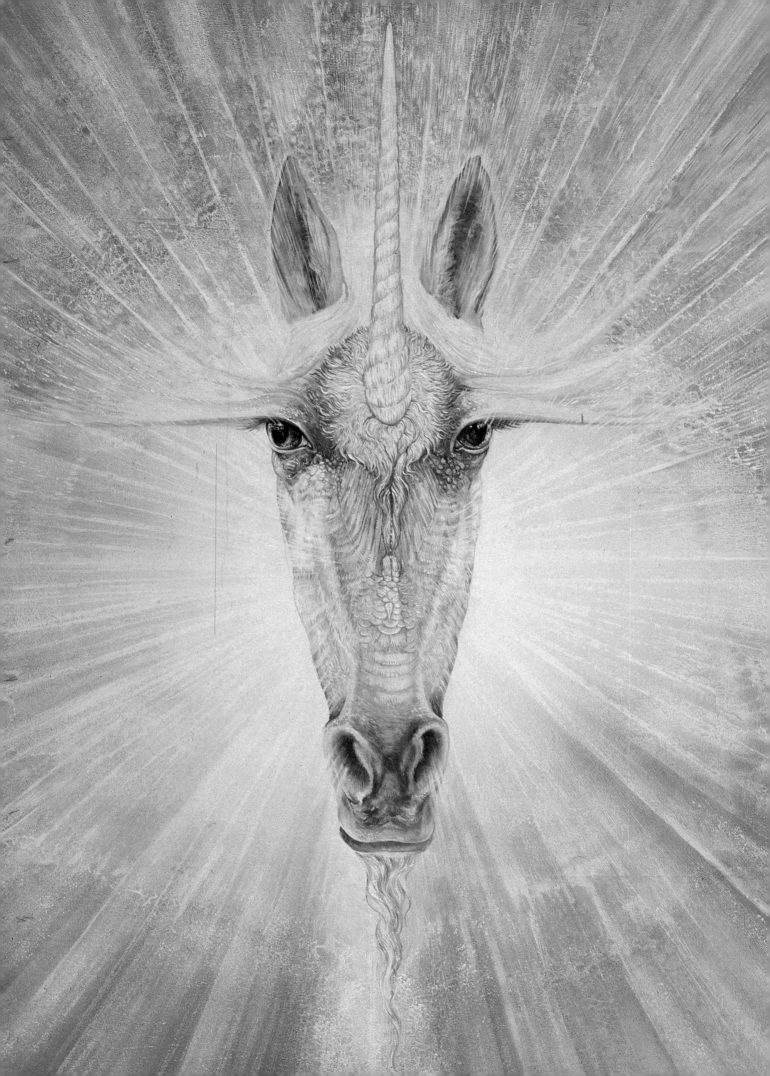

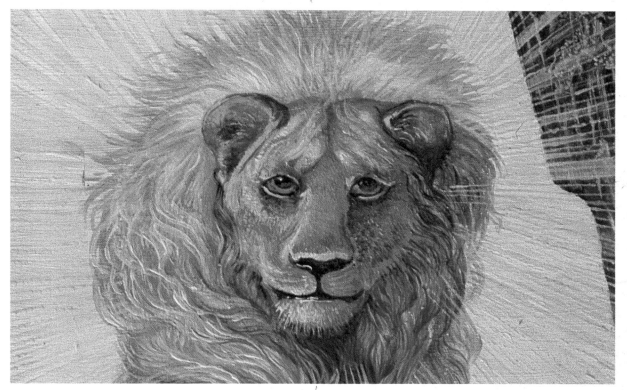

▲ *Sunlight*
◄ *Moonlight*

Some versions say that occasionally the outcome is reversed, that the Unicorn impales the Lion before he can reach the tree, and this gives a clue to the tale's real meaning. Many animal tales arise simply from direct observation of nature, but a few others, like this one which echoes throughout different cultures all around the world, seems to strike a chord in the human soul. In this case it is almost certain that the story encapsulates, in a poetic way, a drama we witness in the heavens every month as the new moon chases the sun across the sky, falling ever further behind but waxing as it does so until finally it is charging towards the sun from the opposite direction, its crescent horn growing ever more slender and sharp. Then the sun devours it and for a few days

and nights the moon disappears from the sky to await rebirth. On the rare occasion of a solar eclipse, though, the tables are turned and it is the sun that briefly dies in the sky.

The Lion as a solar symbol is an established truth in astrology. The Unicorn is not quite as widely accepted as a creature of the moon but the association has always been there and was certainly the common view at the time of James I, who spelled it out himself in a written comment on the heraldic Unicorn. In heraldic terms, the Lion and Unicorn not only represents the union of two formerly warring nations but shows that the new order of things was supported by the balanced forces of nature, sun and moon in harmony.

Politics and heraldry combined to revive

an ancient symbol in the seventeenth century, and along the way the Unicorn acquired a fresh significance. Much of this came from Christianity which, from the Church Fathers onward, saw a close parallel between Christ and the mystic beast. As Honorius of Autun put it: 'The very fierce animal with one horn is called Unicorn. In order to catch it, a virgin is placed in a field; the animal then comes to her and is caught, because it lies down in her lap. Christ is represented by this animal, and his insuperable strength by its horn. He, who lay down in the womb of the Virgin, has been caught by the hunters; that is to say, he was found in human shape by those who loved him.'

St Ambrose, bishop of Milan in the fourth century, said: 'Who then has only one horn unless it be the only begotten son, the unique word of God, which has been next to God from the very beginning? If therefore horns grow in some sense out of the head of our souls, then they denote a process of perfecting the virtues.'

A medieval Latin hymn calls Jesus the 'wild, wild Unicorn whom the Virgin has tamed', drawing a parallel with the fierce God of the Old Testament who was tamed in Mary's lap.

The idea lingers on in a German folk song collected by Ludwig Uhland in the early nineteenth century:

> *The Unicorn is noble;*
> *He knows his gentle birth,*
> *He knows that God has chosen him*
> *Above all beasts of earth.*

> *The Unicorn is noble;*
> *He keeps him safe and high*
> *Upon a narrow path and steep*
> *Climbing to the sky;*

> *And there no man can take him,*
> *He scorns the hunter's dart,*
> *And only a virgin's magic power*
> *Shall tame his haughty heart.*

> *What would be now the state of us*
> *But for this Unicorn,*
> *And what would be the fate of us,*
> *Poor sinners, lost, forlorn?*

> *Oh, may He lead us on and up,*
> *Unworthy though we be,*
> *Into His Father's kingdom,*
> *To dwell eternally'*

Because of the religious parallel, the Unicorn became a popular crest of cardinals and bishops and thus came to adorn their churches. Its solitary state led to the Unicorn also becoming a favourite emblem of hermits and monastic establishments. At the same time, and perhaps more tellingly since they were the founders of dynasties, the Unicorn was enthusiastically adopted by the knights and nobles who ruled medieval Europe.

Most knights subscribed to the code of Chivalry which helped temper the lot of the common man. As a symbol of this ideal the Unicorn was almost perfect, far better than the Lion which was the other favoured device. Noble, wise and slow to anger, indomitable when aroused and with a

Taming of the Unicorn ▶

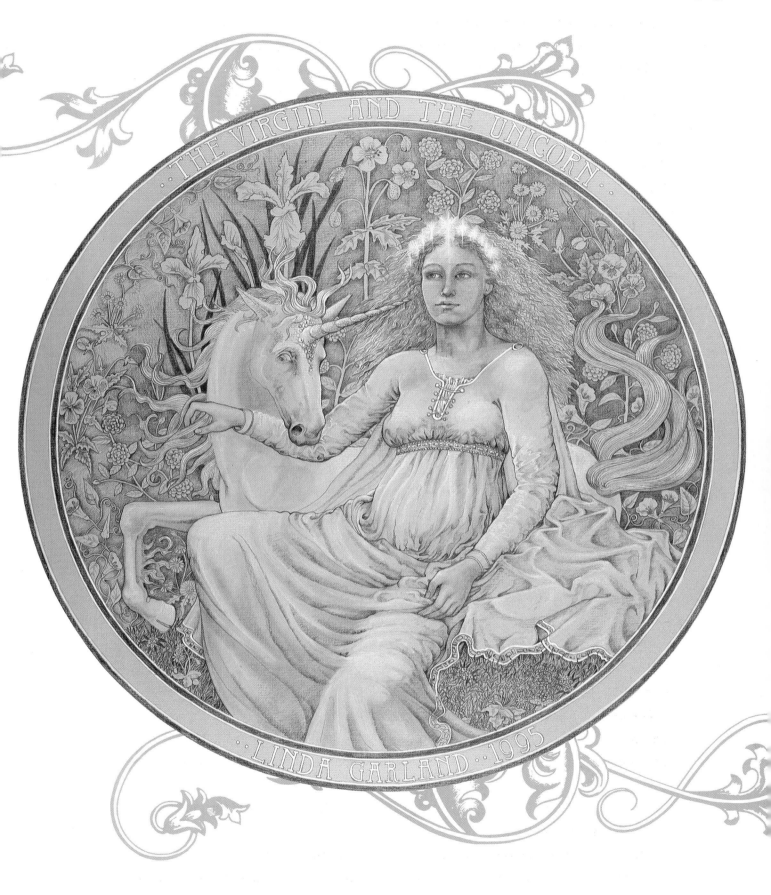

special reverence for women, the Unicorn represented the civilizing, moderating influence of Chivalry. The Lion, conversely, stands for the brutal reality of the kill and, whatever his ideals, the medieval knight had to be able to live by the sword. Ultimately, only the strong survive and a tyrant could only be overthrown by someone more powerful. So even the most Unicorn-minded knights had constantly to hone and exercise their fighting skills. In the absence of real wrongs to champion, they did so by challenging each other to friendly though often fatal jousts.

Take the case of Jaques de Lalaing. In 1449, approaching his thirtieth birthday, he set himself the task of overcoming in battle at least thirty other knights in the remaining year. To this end he picked a spot near Chalon-sur-Saone on the route through Burgundy used by knights heading for a jubilee in Rome. He set up camp by a tree dedicated to Charlemagne and a spring which he dubbed The Fountain of Tears, and on the first day of each month he challenged the passing knights. In a pavilion he positioned figures of a Unicorn and a maiden beneath a picture of the Virgin Mary. Outside the tent were three shields depicting different forms of combat (perhaps lance, sword and mace), and any passing knight had only to fling a gauntlet at one to take up the challenge.

At the day's end the combatants retired for a feast at a nearby bishop's palace. It was all very gentlemanly and civilized, and if any major injuries were sustained they went unrecorded. Sir Jaques failed to reach

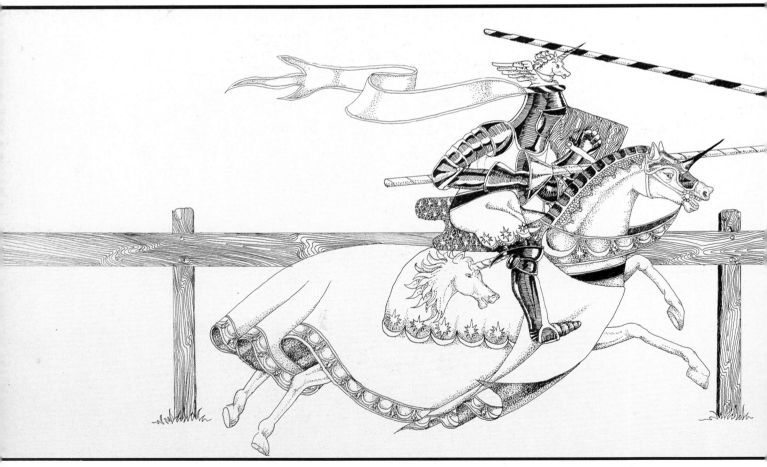

▲ Jousting Knights

his target though and managed only twenty-two conquests in the year. As fate would have it, he died a couple of years later in serious battle.

During the Middle Ages the Unicorn also came to be associated with chastity despite rumours that its interest in maidens was not wholly platonic. In a Provençal story of a Unicorn hunt, the Unicorn is said to have nuzzled the maiden's breasts and attempted other familiarities before she led him away firmly by the horn.

For alchemists, the Unicorn was thought to play a significant part in their quest for spiritual gold, alongside the lion, eagle and dragon. In the very rare *Book of Lambspring* is an engraving of a deer and Unicorn standing together in a forest, with a caption that reads: 'The sages say truly that two animals are in this forest; one glorious, beautiful and swift, a great and strong deer; the other a Unicorn. If we apply the parable of our art, we shall call the forest the body. The Unicorn will be the spirit at all times. The deer desires no other name but that of the soul. He that knows how to tame and master them by art, to couple them together and to lead them in and out of the forest, may justly be called a Master.'

Mylius outlines the seven stages of the alchemists' work by a series of symbols, the sixth of which is a Unicorn crouched under a tree and representing the life spirit that leads the way to resurrection.

Heraldry sprang from a lively tradition which still had great impact on the popular mind at the opening of the seventeenth

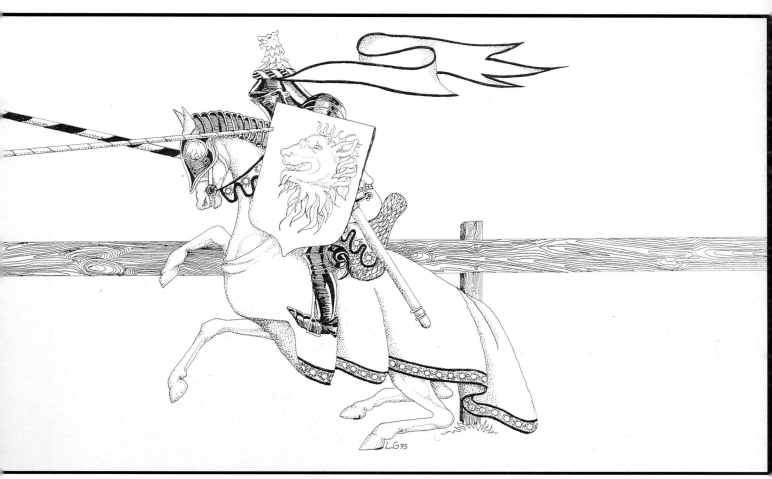

(next page) 'The Unicorn will be the spirit at all times'

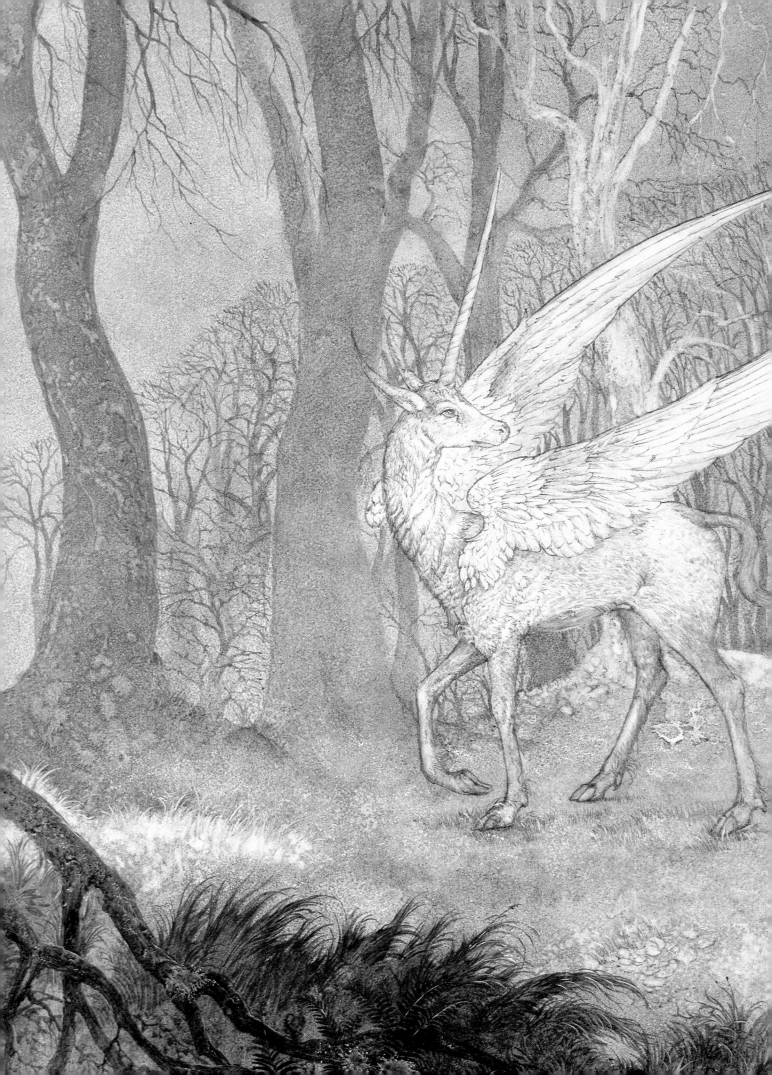

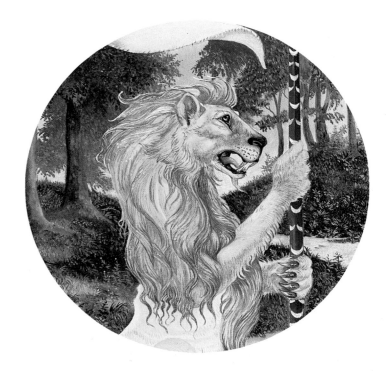

century. When the Unicorn appeared on the royal coat of arms of England and Scotland, all the scattered lore which had accumulated around the beast over the ages suddenly gained fresh currency. The pride that leads the Unicorn to choose death over capture; the water-conning trick by which its horn dispels poison; its gentleness towards friends and ferocity with enemies; its strength and solitary inclinations; its devotion to beautiful women and epitomizing of both the Christian and Chivalric ideals – all these and other associations were given fresh life and prominence at a time when they could have slipped into obscurity along with other Medieval lore.

The Lion and Unicorn are natural enemies and destined to fight but nowhere is it suggested that they represent good and evil. At best, like sun and moon, they are complementary; at worst they are incompatible. Both have, at times, been called the lord of all beasts but their styles of sovereignty are totally different. Extrovert and introvert, fiery and cool, what they represent is opposite principles which are fine in themselves as long as they are not in competition.

In Christianity the Unicorn was nearly always seen as a symbol of Christ but this did not lead to his enemy, the Lion, becoming a figure of Satan. Paradoxically, the Unicorn was also on occasion taken to represent death and the Devil. St Basil of Caesarea was one of the first to put forward this view. After quoting Psalm 22, in which David prays to be saved from the mouths of Lions and the horns of Unicorns, he continues: 'And take heed unto thyself, O Man, to protect thyself from the Unicorn, who is the Devil. For he plotteth evil against man and is skilled in doing him harm. For he stands by the way day and night, and by permeating man with his sophistries severs him from God's commandments.'

The ambivalence of the Unicorn is shown in the *Mabinogion* tale of Peredur, an early Grail Quest legend. For losing a magic gaming board, Peredur is told to slay a Unicorn described by a certain Dark Maid as: 'A stag, swift as the swiftest bird, and there is one horn in its forehead the length of a spear-shaft, and it is as sharp of point as aught sharpest-pointed. And it browses the tops of the trees and what

herbage there is in the forest. And it kills every animal it finds therein. And those it does not kill, die of hunger. And worse than that, it comes every night and drains the fish pond in its drinking, and leaves the fish exposed, and most of them die before water comes thereto again.'

Peredur tracks down the Unicorn and, when it charges him, ducks aside and strikes off its head with a sword. Then another lady comes along on horseback and rebukes him for having slain: 'The fairest jewel that was in my dominion.'

Peredur, being honour bound to obey every female he meets, then has to pay another forfeit before he can go on his way. The question of which female was telling the truth about the Unicorn is left unresolved, but presumably both possibilities were acceptable to the *Mabinogion*'s original audience.

James of Viraggio, Archbishop of Genoa in the thirteenth century, published a collection of parables called *The Golden Legend* which contained a widely popular tale believed to have come originally from India: 'Once there was a man named Barlaam who lived in the desert near Senaah and who often preached against the illusory pleasure of the world. Thus he spoke of a man fleeing in haste from a Unicorn who would devour him. Falling into a well, he happened to catch hold of a bush but failed to find a proper foothold. With the raging Unicorn glaring down on him from the rim of the well, he caught

sight of a dreadful fiery dragon waiting with open maw for him to drop. From the narrow ledge on which he was teetering, four serpents distend their fangs. A pair of mice, one black and the other white, gnaw away at the roots of the bush to which he is clinging, while the bush itself is about to break off. But as he lifts his eyes, he spots honey dripping from the branches of the bush and, forgetting all about his peril, he surrenders himself fully to the sweetness of the honey.

'The Unicorn, as Barlaam expounded in his parable, was death which pursues man everywhere. The well was the world filled with every evil. The bush was human life finally extinguished by the steady erosion of day and night, represented by the mice. The four serpents stand for the human body composed of the four elements which must disintegrate if they become disturbed. The dragon is the bottomless pit of Hell

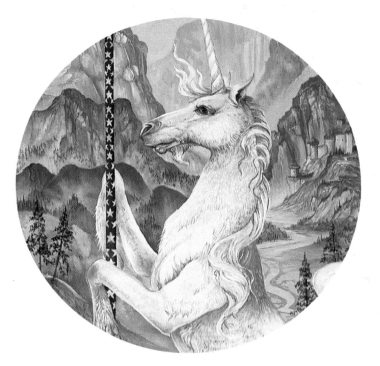

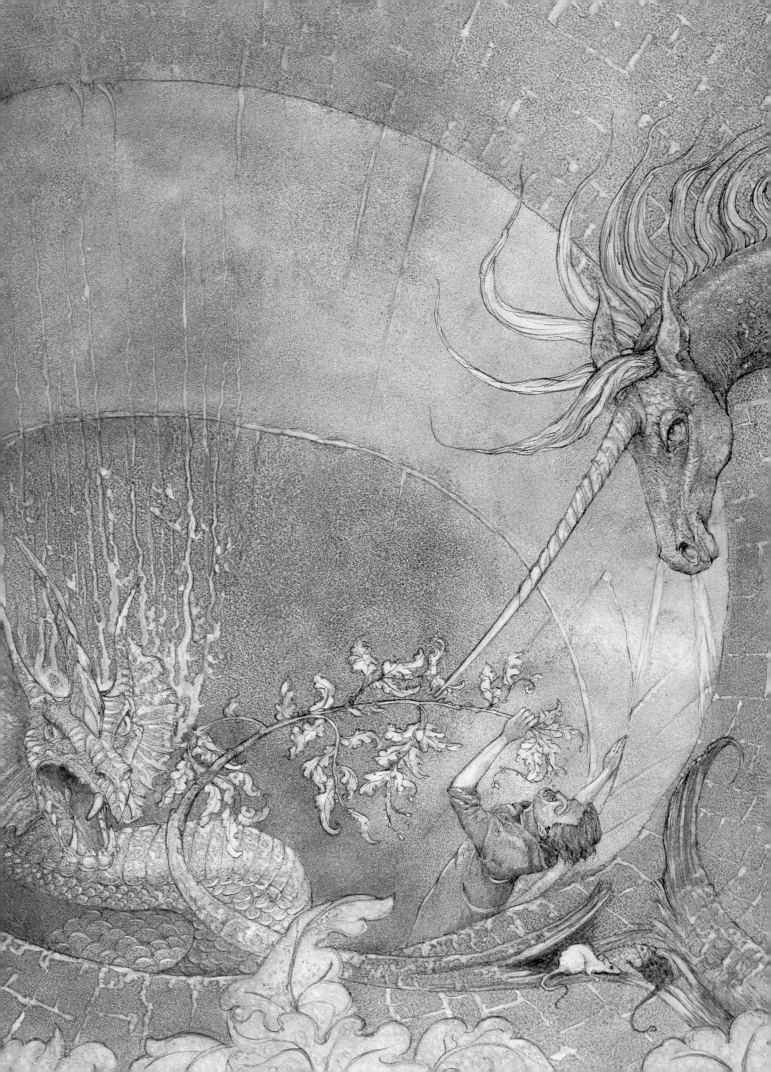

threatening to swallow up mankind. But honey is the worldly pleasure to which man surrenders, forgetting all peril.'

Such preaching may seem at first to jar with everything else that has been said about Unicorns, but there is a sense in which it completes the picture. As a champion of the moon it would be surprising if the Unicorn did not have a shadow side. The moon is the beneficent controller of tides and fertility and was once believed to draw poisons out of the earth while it slept. In astrology the moon stands for cool, calm reflection and is seen as the factor mediating between past and present, weaving fresh experience into the whole fabric of life.

But there is also the dark side of the moon that is the fount of nightmares and lunacy, and this is reflected in the Unicorn's nature.

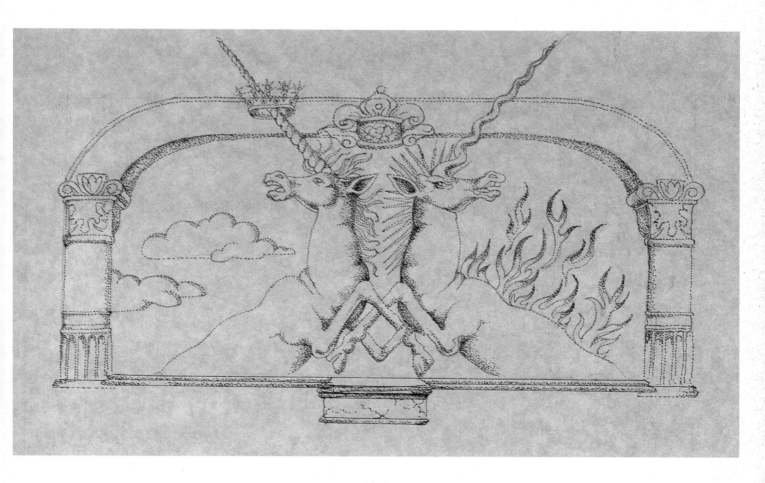

◄ *Barlaam and the Well* ▲ *Good and Evil*

CHAPTER 4

Unicorns

The earliest recorded tales of Unicorns came from India and descriptions of the one-horned 'Indian wild ass' have remained remarkably consistent over the centuries. However, Indian tradition has never afforded the Unicorn the same reverential status it received in the West.

The Unicorn was considered a marvel of the animal kingdom but not its greatest marvel. Perhaps this was because its favourite haunts in the Himalayas abounded with so many other marvellous creatures that it paled by contrast. Possibly, Indian culture was less in need of the Unicorn as a symbol for what it lacked. Whatever the reason, in India it remained pretty much an also-ran among marvels, except where Buddhism prevailed and the association with the Master was kept alive.

Legend has it that when the Buddha delivered his famous sermon at Benares, a

in the East

Unicorn came and knelt at his feet to listen. Depicted as a one-horned gazelle, its single curved horn was seen as a symbol of Nirvana. The beast itself was viewed as a model of good behaviour, as exemplified in this long Buddhist hymn which, among other things, tells the aspirant:

The deer untethered roams the wild
Where it wishes in search of food.
Seeing this liberty, wise man,
Fare solit'ry as the Unicorn.
Free everywhere and at odds with none
Content with what comes your way
Enduring peril without alarm,
Fare solit'ry as the Unicorn
Like a lion fearless of the howling pack
Like the breeze ne'er trapped in a snare
Like the lotus unsoiled by its stagnant pool,
Fare solit'ry as the Unicorn.

In Tibet, where a colourful strain of Buddhism became the national religion, the Unicorn was widely celebrated in art and sculpture, but nowhere in the East has it been more highly venerated than in China.

(next page)
The Chinese Creation

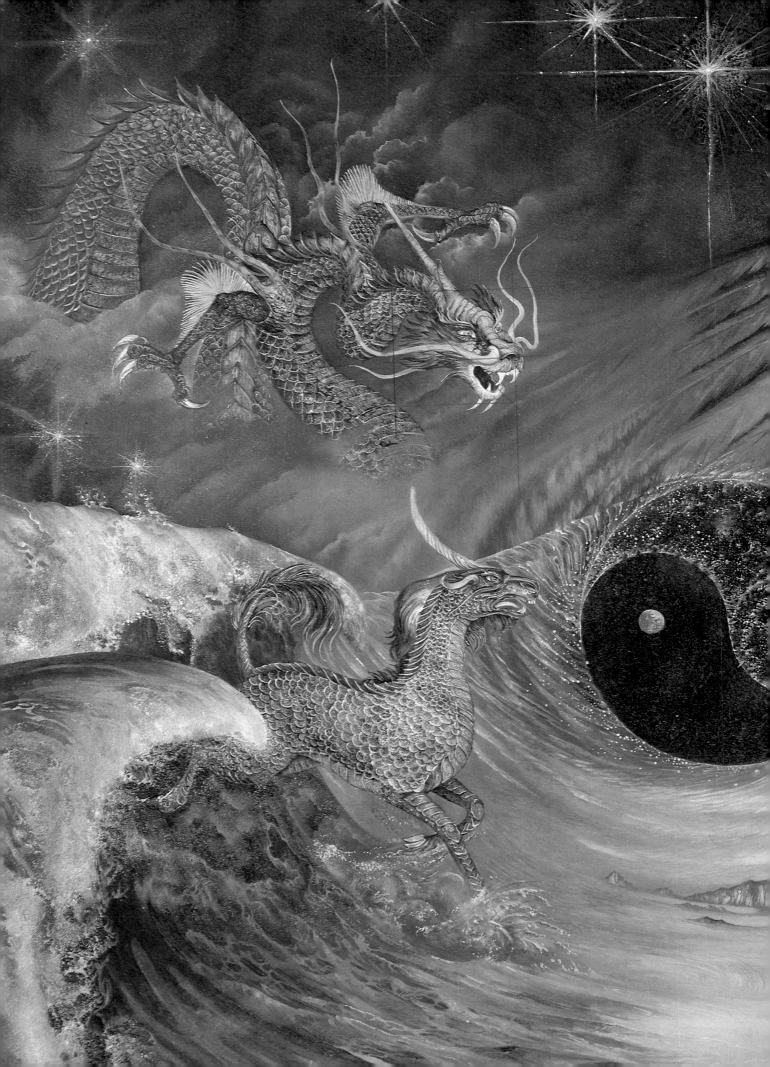

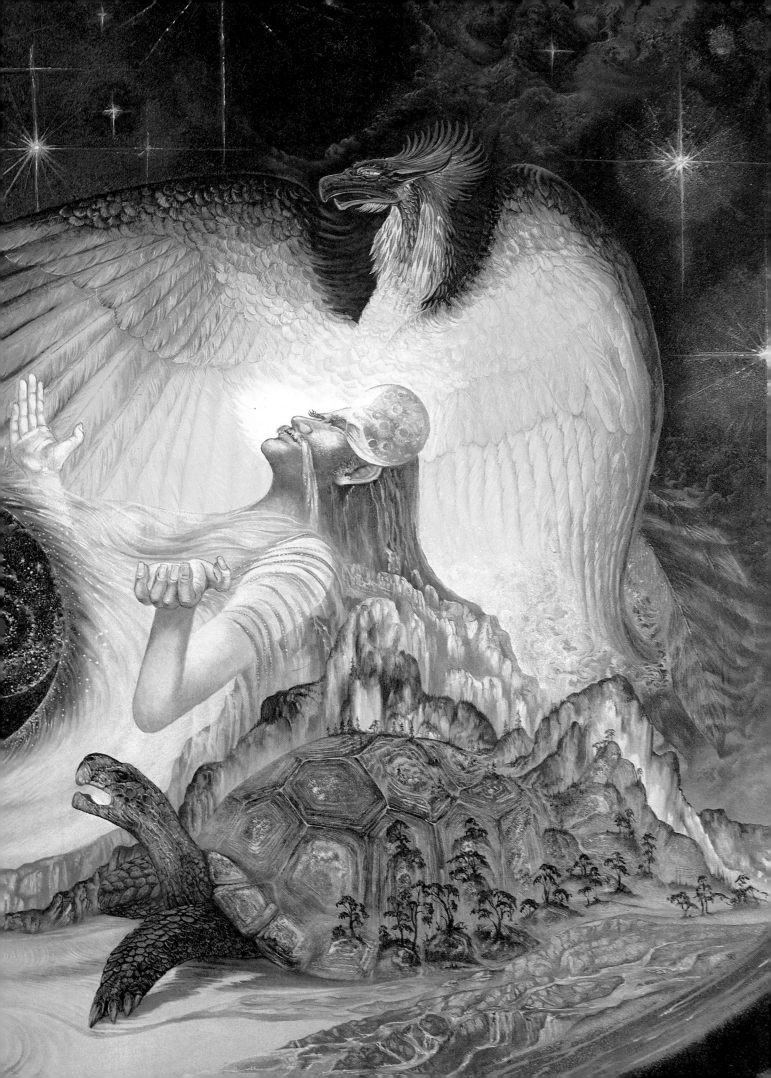

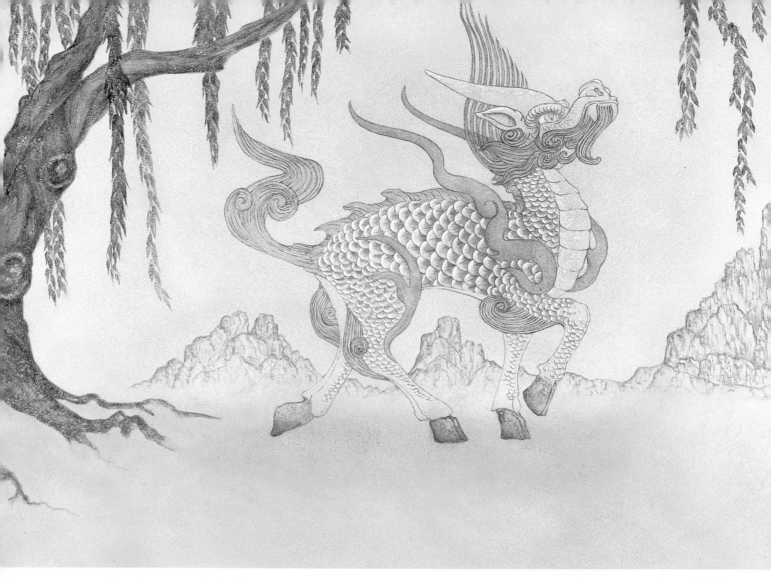

The Creation

ur knowledge of very early Chinese myth is fragmentary, thanks to a cultural revolution in about 213 BC when the Emperor Shi Huang Ti, after unifying the country, ordered the burning of all but purely technical books to try and make a break with the past. Considering that the penalty for disobedience was death, a surprising number of scholars defied the ban and some 460 are known to have paid the price. The purge was ruthless but some of

the proscribed literature survived, among it this account of the Creation, preserved and disseminated by the Taoist religion.

'Before the world came into existence there was only the Cosmic Egg that floated unchanging in the Void for untold ages. Yin and Yang was the Egg, opposites perfectly mingled. And it was because they were perfectly mingled that the world could not yet be.

'Then within the Egg was born P'an Ku, the primordial man who slowly grew and

grew until the Egg felt too cramped for him. Impatiently he stretched out his limbs and his hand closed about an axe, coming from whence no one knows. Striking with all his might, P'an Ku split the shell of the Egg and burst free.

'He then began to fashion the material of Chaos, separating Yin and Yang into sky and earth, in which he was aided by the four most fortunate creatures who had emerged from the Egg with him: the Unicorn, the Dragon, the Phoenix and the Tortoise. They were engaged in this labour for 18,000 years and each day P'an Ku grew ten feet, using his own body as a pillar to force heaven and earth apart.

'When the separation was complete and they had settled in their places, P'an Ku died. His breath became the wind and clouds, his eyes became the sun and moon. His stomach, head and limbs became the principal mountains of the world, watered by the rivers of his sweat and tears; his flesh became the fertile soil and his hair the plants and trees which took root in it. The fleas on his body became the human race. Then P'an Ku drifted in space for a further 18,000 years before entering a holy virgin as a ray of light and being born into the world by her as Tien-Tsun, the First Cause.'

The four most fortunate creatures, also called the four intelligent beasts, were dispersed all over the world. In China, the Unicorn became known as the Ch'i-lin (also spelt Ki Lin, Chhi Lin or, from the Japanese, Kirin). Strictly speaking, Ch'i means the male Unicorn and Lin the female but usually the combined form is applied to both.

Like its Western cousin the Ch'i-lin is an elusive creature which evades captivity and has an even greater reputation for gentleness and wisdom. The Ch'i-lin took a particular interest in the government of China and its appearance at the Imperial Court was seen as a portent of either the beginning or the end of a glorious reign.

The Book of Rights describes the Ch'i-lin as: 'Chief among four-footed beasts. It resembles the stag but is larger. It has a single horn, the tip of which is fleshy, indicating that it is not used in battle. There are five colours in the hair of its back – red, yellow, blue, white and black – and the hair of its belly is dark yellow. It does not tread any living grass underfoot nor eat any living creature. It shows itself when perfect rulers appear and when the Tao of the King is accomplished.' That is to say, when the ruler's work is well done and his time has come, the Ch'i-lin arrives to bear his soul to Heaven.

After a similar description The Shu King goes on to say: 'Its call in the middle part is like a monastery bell. Its pace is regular. It rambles on selected grounds and only after it has examined the locality. It will not live in herds or be accompanied in its movements. It cannot be beguiled into pitfalls or captured in snares.'

The Royal Ch'i-lin

he earliest recorded appearance of the Ch'i-lin was to the legendary sovereign Fu Hsi c. 2900 BC. Fu Hsi is credited, among other things, with domesticating animals, breeding silkworms and teaching the art of fishing. He also invented music and the set-square and compasses to measure the earth. He and his wife Nu Kua restored order to the world after it had almost been destroyed by the monster Kung Kung, not least by their invention of marriage as a means of harmonizing the Yin and Yang of human nature.

The Lieh Tzu says of Nu Kua: 'In oldest times the Four Cardinal Points were out of place, the Nine Provinces lay open, the sky did not wholly cover the earth, the earth did not wholly support the sky, fire burnt ceaselessly without dying out, the waters flowed on without ceasing, wild beasts devoured the peaceful people, and birds of prey carried off children and the aged. Then Nu Kua smelted the stones of five colours to repair the azure sky. She cut off the feet of a tortoise to fix the Cardinal Points. She slew the black dragon to save the country of Chi and she piled up ashes of reeds to stem the overflowing waters. All was tranquil at that time, everything was at peace.'

Towards the end of his industrious life Fu Hsi was sitting one day on the bank of the Yellow River. He was pondering mortality and the problem of how to record his thoughts for posterity (writing was yet to be invented). Suddenly a Ch'i-lin rose out of the waters and approached him. On its back it carried certain magical sigils from which Fu Hsi was able to devise the first written language of China. The script has evolved so naturally that today it is still possible for a reader of modern Chinese to understand something written 2,000 years ago.

The signs which inspired Fu Hsi were the Pa Kua or eight trigrams. These symbolic combinations of broken and unbroken lines are the basis not only of Chinese writing, but also of the philosophic and divinatory system which has been handed down to us as the *I Ching*, or Book of Changes. Fu Hsi is one of its four credited authors, along with King Wen, the Duke of Chou and Confucius.

Fu Hsi's trigrams have had an enormous and continuing influence on Chinese thought and culture. The *I Ching* conveys a distinct and original philosophy that helped create one of the world's great civilizations. The Pa Kua may have fallen from favour somewhat in modern China but many of the ideas they gave rise to live on. The symbols themselves are familiar to many Western eyes from their presence on the Korean national flag.

The *Pai Hu T'ung* written in the first century AD (by, curiously enough, one Pan Ku) was not exaggerating popular opinion when it stated: 'In the beginning there was

Suddenly a Ch'i-Lin rose out of the waters ▶

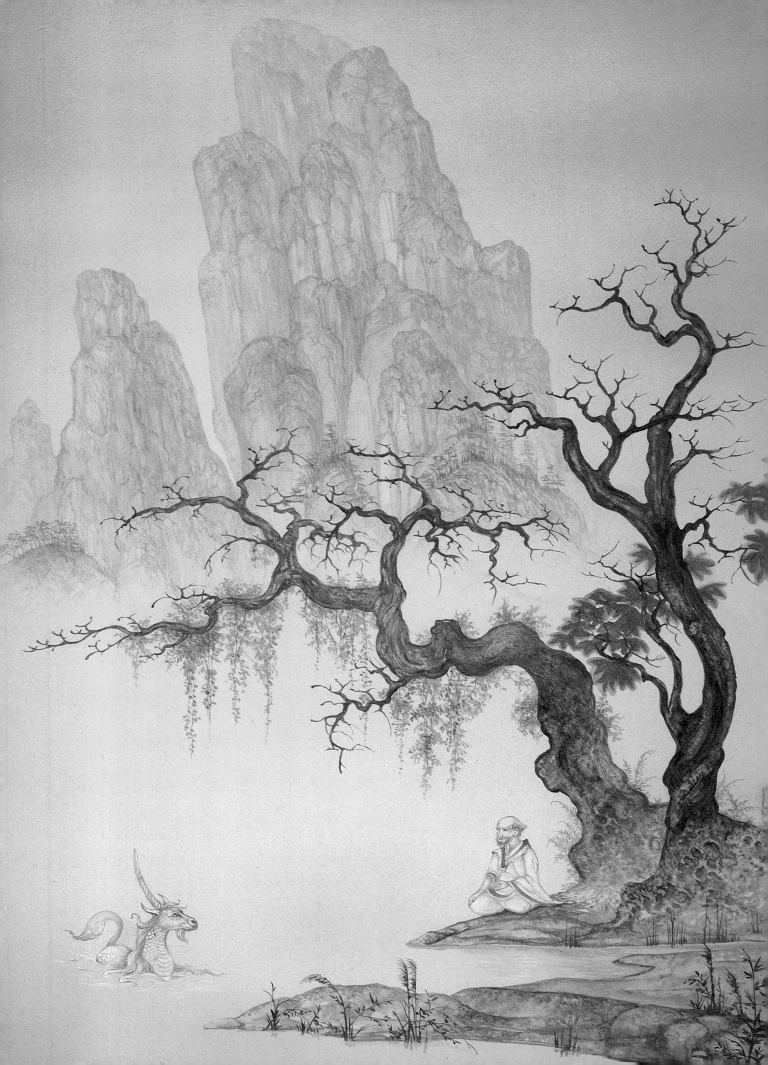

as yet no moral or social order. Men knew their mothers only, not their fathers. When hungry, they searched for food; when satisfied they threw away the remnants. They devoured their food, hide and hair, drank the blood, and clad themselves in skins and rushes. Then came Fu Hsi and looked upward and contemplated the images in the heavens and looked downward and contemplated the occurrences on earth. He united man and wife, regulated the five stages of change, and laid down the laws of humanity. He devised the eight trigrams in order to gain mastery over the world.'

Thus the Ch'i-lin, who helped create the world, also played a significant part in making it bearable for mankind.

Fu Hsi was followed as sovereign by Shen-nung, who taught his people the arts of agriculture and herbalism. Despite this, he offended Heaven in some way because the Ch'i-lin made no appearance and his land suffered a severe drought. He was saved in the end only by the personal intervention of the Lord of Rain.

Huang Ti came next, known also as the Yellow Emperor or the August Sovereign. He was the first of five semi-divine Emperors who ruled pre-dynastic China, and is credited with the invention of the chariot wheel, magnetic compass and potter's wheel. He also wrote a classic treatise on medicine, and is said to have found the recipe for a pill which conferred both immortality and the ability to make gold from base metals. Some copies of his book were believed to contain the recipe but none have survived, despite the prolonged searching of many of his successors.

Warfare and weapons also came into

being during Huang Ti's reign, when the son of his predecessor, and now one of his ministers, staged a rebellion against him. The Yellow Emperor countered the insurrection by devising weapons and armour to protect his men. Various deities were also drawn into the contest on both sides and used their mastery of the weather to influence the course of the battle. In fact, it was a thick fog conjured up by his enemy that inspired Huang Ti to invent the magnetic compass to guide his armies.

In the end Huang Ti was victorious and went on to become one of the most revered of all Chinese rulers. The Bamboo Books record the appearance of a Ch'i-lin at his palace in 2697 BC, shortly before his death; and during the reigns of the following four Emperors, in what came to be seen as a Golden Age of peace, justice and good government, the Ch'i-lin often appeared as a mark of approval.

The last of the Five Emperors was Shun and his chief minister of justice was named Kao-yao. His judgements were so highly praised that he adopted the Ch'i-lin as his emblem and was often assisted by a Unicorn in his court. Whether this was a true Ch'i-lin is uncertain. It may well have been one of the several other species of one-horned beast known to the Chinese. Some accounts suggest a single horned ram or goat, but one which possessed a spark of the true Ch'i-lin power to tell right from wrong. When unable to decide a case, Kao-yao would present the plaintiffs to this beast and with its horn it would choose between them. Its decision often resulted in the execution of the guilty party.

Divine Emperor ▶

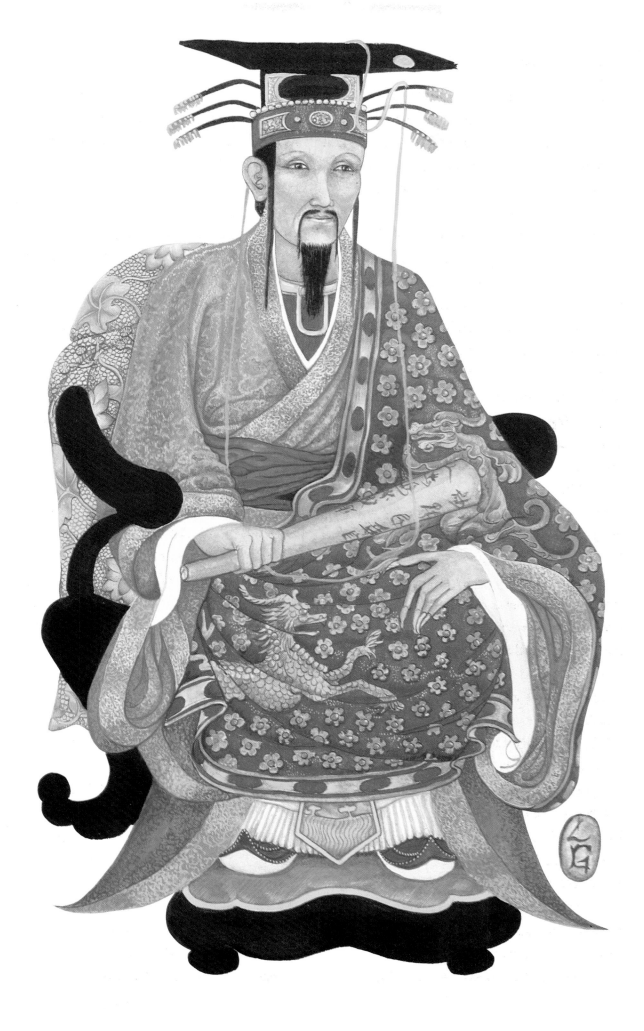

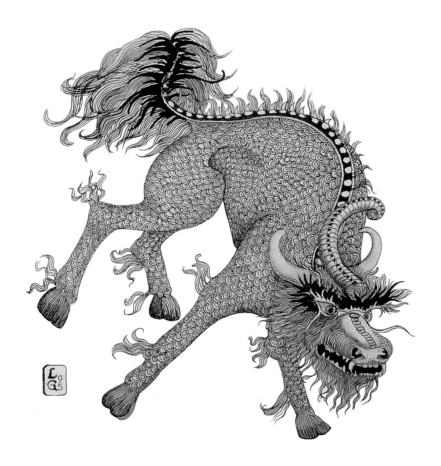

Confucius & the Unicorn

s the early, enlightened Yellow Emperors gave way to lesser men, the Ch'i-lin was seen increasingly rarely in the palace gardens, until finally they ceased to appear at all. By the sixth century BC, China was nominally ruled by the Chu dynasty, but had effectively disintegrated into a number of mutually hostile states. The Ch'i-lin was but a distant memory throughout most the land.

At this time there lived at Tai Shan, in the province of Lu, a pious woman. Her only sorrow was that she and her husband had no son, for which she prayed constantly and fervently to heaven. When after a long while her prayers were still unanswered, she determined to make a pilgrimage to a holy shrine in the mountains. On the way a Ch'i-lin appeared to her, knelt and dropped from its mouth a piece of jade bearing the inscription: 'The son of the mountain crystal, the essence of water, will perpetuate the fallen kingdom of Chu and be a King without a crown.'

In due course the woman bore a son called Kung Fu Tse, better known to us as Confucius, for whom the title 'King without a crown' could hardly be more apt. Through his teachings, Confucius probably shaped the course of Chinese thought and history more than any Emperor, without ever holding high office himself.

Some seventy years later, while engaged

in writing his *Spring and Autumn Annals*,
a philosophical history of his home state,
Confucius heard news from a disciple of a
strange beast that had been killed nearby.
A party of noblemen led by Duke Ngai of
Lu had surprised the beast by firing the
undergrowth while out hunting. Some say
the creature ran into a chariot and was
killed by accident; others said that the
hunters were merely too quick with their
spears. Either way the animal lay dead and
abandoned at a crossroads.

Accompanying his disciple there,
Confucius recognized the creature at once
and cried: 'It is a Ch'i-lin. The Ch'i-lin,
benevolent beast, appears and dies. My
Tao is exhausted.' Ending his Annals
prematurely with an account of this
incident, Confucius is then said to have
laid down his pen and never written
another word. However, it is possible
that he wrote this poem after seeing the
Ch'i-lin.

> *'In the age of Tang and Yu the Unicorn and*
> *the Phoenix walked abroad.*
> *Now when it is not their time they come*
> *And what do they seek?*
> *The Unicorn, the Unicorn, my heart is sad.'*

Four hundred or so years later a Ch'i-lin
again showed itself to an Emperor of China,
Wu Ti of the Han dynasty. After spotting a
pure white Ch'i-lin in the grounds of his
palace, Wu Ti added a special gallery to the
building in hope of its return. Sadly, it was
to prove the last time any true Unicorn
gave its blessing to a ruler of China.

Holy Shrine ▶

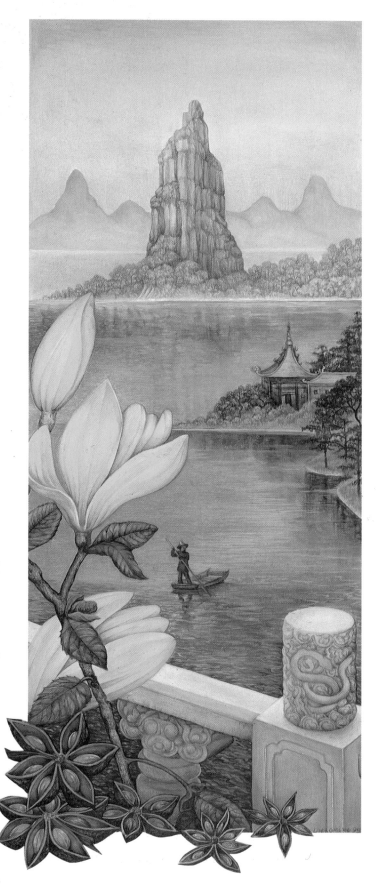

False Rumours

he visit was far from forgotten, however, and with each new Emperor the hope arose again that a Ch'i-lin would show itself at the Imperial palace. In the early fifteenth century during the reign of the third Ming Emperor, Yung Lo, there was great excitement when many people believed that a Ch'i-lin had appeared. They had, in fact, seen a giraffe.

It was a gift from Bengal to Peking and, despite the obvious differences between a giraffe and the now legendary Ch'i-lin, the Emperor was so popular that many people wanted to believe it was a Unicorn. The Emperor, however, was sufficiently clear-headed and modest not to play along with the popular mood. He accepted the gift of the giraffe for what it was, an exotic addition to the Imperial zoo, rather than a blessing on his reign.

The following year, 1415, the whole fuss was repeated when the Emperor's own jewel ships returned from an expedition to East Africa with another giraffe on board. What is more, the Three Jewel Eunuch leading the venture reported that the natives who had procured it had called the beast a Ch'i-lin. However, it later transpired that the Somali word for giraffe is 'girin', and the eunuch had been understandably confused.

▲ *The Emperor's menagerie*

The Emperor was still not convinced. He did accept the giraffe in a state ceremony at the Perfumed Gate and acknowledged it as an auspicious animal, but no more so than the zebra and oryx which arrived with it. Whatever accolade the creatures bestowed, he diplomatically attributed this to his father and the many ministers of his government.

His response to all this only served to increase his reputation for humility, as shown in this eulogy by the poet Shen Tu of the Imperial Academy:

'Now in the twelfth year, in a corner of the Western Sea, in the stagnant waters of the great marsh, a Ch'i-lin has in truth been found; some fifteen feet in height, its body that of a deer and with the tail of an ox, with a fleshy horn without bone and luminous spots like red cloud in a purple mist. Its hooves do not trample on living creatures and it moves with careful tread, walking in a stately manner and with a continuous rhythm. Its harmonious voice has the sound of a bell or musical chime. Benevolent is this creature whose manifestation of divine spirits reaches up to the abode of Heaven. Ministers and people together vie to be the first to gaze upon the joyous spectacle, a true token of Heaven's aid and a proclamation of Heaven's favour. How glorious is the Sacred Emperor whose literary and military virtues are most excellent, who has succeeded to the Precious Throne and has achieved Perfect Order in imitation of the Ancients.'

The true Ch'i-lin may have retreated into obscurity but it was far from forgotten. Until the upheavals of the twentieth century, millions of Chinese women, when pregnant, hung pictures of it around the house in the hope of receiving the creature's blessing on their offspring. An image of a Ch'i-lin was also embroidered on the crimson chair which carried a bride to her groom's house. Another variation included gods riding on the Ch'i-lin's back, which express the parents' wish for perfect children.

Until recently the greatest compliment to pay someone in China was to say that a Ch'i-lin must have appeared at the time of their birth. There is also a traditional belief that at some time in the future, signalled by the stars, the Ch'i-lin will appear in human form on a mission of redemption.

Seekers and Sightings

or as long as tales of Unicorns have been in circulation, Tibet has been rumoured as one of their favourite haunts. One of the most famous travellers in that region, Abbe Huc, said in the account of his visit in the 1840s:

'The Unicorn, which has long been regarded as a fabulous creature, really exists in Tibet. You find it frequently represented in the sculptures and paintings of the Buddhist temples. Even in China you often see it in the landscapes that ornament the inns of the northern provinces. We had for a long time a small Mongol treatise on Natural History, for the use of children, in which a Unicorn formed one of the pictorial illustrations. The Chinese Itinerary says, on the subject of the lake you see before your arrival at Atzder (going from east to west), "The Unicorn, a very curious animal, is found in the vicinity of this lake, which is forty Li long." But the inhabitants of Atzder spoke of it without attaching to it any greater importance than to the other species of antelopes which abound in their mountains.'

The Tibetans and their neighbours didn't believe that all one-horned animals were Unicorns. They knew some of them were simply one-horned variants of more common beasts, such as Hodgson's Antelope, which was known to the Mongols as the orongo. In his book on Mongolia, Colonel Prejevalsky says:

'The orongo is held sacred by Mongols and Tangutans, and lamas will not touch the meat. The blood is said to possess medicinal virtues, and the horns are used in shamanism: Mongols tell fortunes and predict future events by the rings on these and they also serve to mark out the burial places, or more commonly the circles

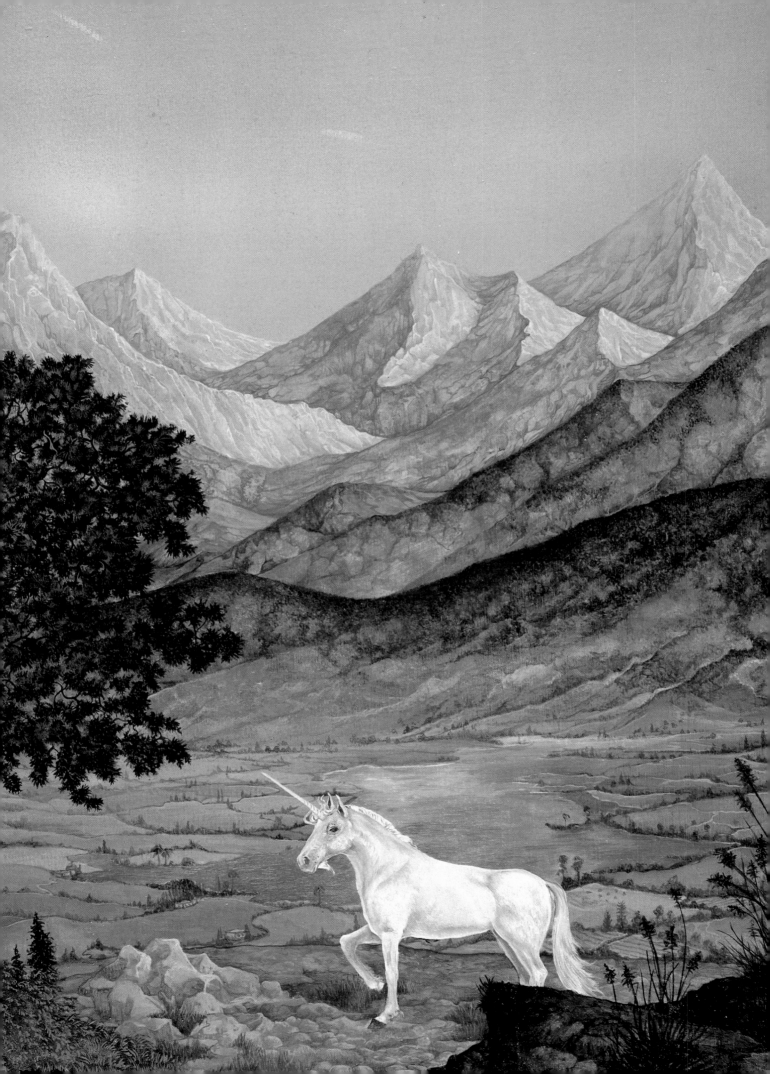

within which the bodies of deceased lamas are exposed: these horns are carried away in large numbers by pilgrims returning from Tibet and are sold at high prices. Mongols tell you that a whip handle made from one will prevent a rider's steed from tiring. Another prevalent superstition is that the orongo has only one horn growing vertically from the centre of its forehead. But in Kan-su and Koko-nor we were told that unicorns were rare, one or two in a thousand.'

The Abbe Huc's English translator, Hazlitt, records that Hodgson himself managed to acquire the skin and horn of one such unicorn when it died in the menagerie of the Rajah of Nepal; he sent it to Calcutta.

Captain Samuel Turner, ambassador to Tibet in the late eighteenth century, wrote of a conversation with the Rajah of Bhutan: 'He had a very curious creature, he told me, then in his possession; a sort of horse, with a horn growing from the middle of his forehead. He had once another of the same species, but it died. I could not discover from whence it came, or obtain any other explanation than *burra dure* (a great way off). I expressed a very earnest desire to see a creature so curious and uncommon, and told him that we had representations of an animal called a Unicorn, to which his description answered; but it was generally considered fabulous. He again assured me of the truth of what he told me, and promised I should see it. It was some distance from Tassisudon, and his people paid it religious respect.'

◄ *Himalayan Unicorn*

In December 1820 a Major Latter wrote in a letter to the *Quarterly Magazine*: 'In a Thibetan manuscript which I procured the other day from the hills, the Unicorn is classed under the head of those animals whose hoofs are divided; it is called the one-horned tso'po. Upon enquiring what kind of animal it was, to our astonishment the person who brought me the manuscript described exactly the Unicorn of the ancients, saying that it was an inhabitant of the interior of Thibet, fierce and extremely wild, seldom ever caught alive, but frequently shot and the flesh was used for food. The person who gave me this account has repeatedly seen these animals and eaten flesh of them. They go together in herds, like our wild buffaloes, and are very frequently met with on the borders of the great desert about a month's journey from Lassa, in that part of the country inhabited by the wandering Tartars.'

As Major Latter was stationed in the Bhutan area, the Rajah's Unicorn had plainly either died or moved on. Seven years later the *Asiatic Journal* reported that Latter had still not managed to lay eyes on a real living Unicorn despite much searching, and was apparently beginning to lose hope.

Even if his search had proved fruitful, he probably would only have found the one-horned orongo. Like Dr Dove's Unicorn bull, such creatures have undoubtedly fuelled the legend and could be, in fact, its sole source. All the mystique surrounding the Unicorn may, after all, simply be the workings of human imagination.

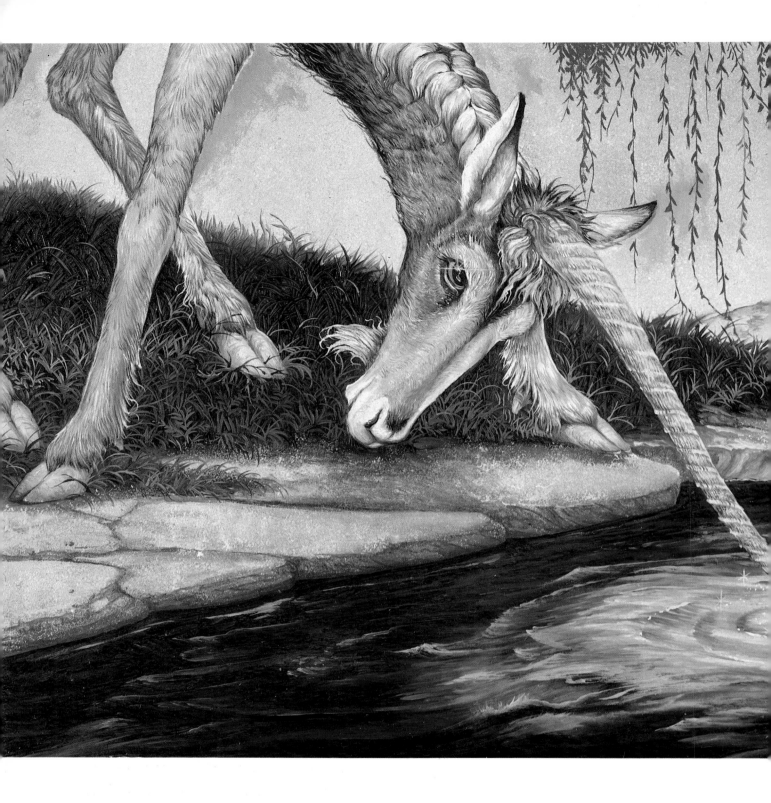

Nevertheless, when we compare the Western and Eastern views of the Unicorn there is a remarkable similarity, despite the fact that the mythologies evolved independently. The main difference is that in China there is no mention of the fierce side of its nature, but neither is there any record of man or beast trying to hunt it down. The Chinese also drew a clear distinction between the Ch'i-lin, or true Unicorn, and the several other species of one-horned animals on record.

Coming nearer to home but jumping a few centuries back in time, two famous and

is the river Marah, whose bitter waters Moses made sweet with a stroke from his staff and the children of Israel drank thereof [Exodus 15:23-25]. To this day, it is said, malicious animals poison this water after sundown, so that none can thereupon drink any longer from the stream. But early in the morning, as soon as the sun rises, a Unicorn comes out of the ocean, dips his horn into the stream and drives out the venom from it so that the other animals may drink thereof during the day. This, as I describe it, I saw with my own eyes.'

In 1483 Friar Felix Faber of Zurich joined a party of pilgrims on almost a package tour of Biblical sites. On return to his Dominican monastery at Ulm he wrote down his experiences, including this incident in the Sinai peninsula:

'Towards noon we spotted an animal gazing down at us from a mountain peak. We thought it was a camel and wondered how a camel might remain alive in the wilderness, and this speculation raised a discussion among us as to whether there might also be forest camels. Our guide Kalin approached us, however, and stated that the animal must certainly be a Unicorn, and he pointed out to us the single horn which jutted from the animal's forehead. With great caution we gazed back at this most noble creature, regretting that it was no closer for us to examine it still more minutely. We rested for some time at the bottom of the mountain where the animal stood regarding us as pleasantly as we regarded it, for it stood still and moved not until we had gone on our way.'

The water conning miracle ▲

more successful accounts deserve mention. Both come from priests who visited the Holy land in the wake of the crusades.

The first was Johannes van Hesse of Utrecht who witnessed a Unicorn at work while on pilgrimage in Palestine in 1389: 'Near the field Helyon in the Promised Land

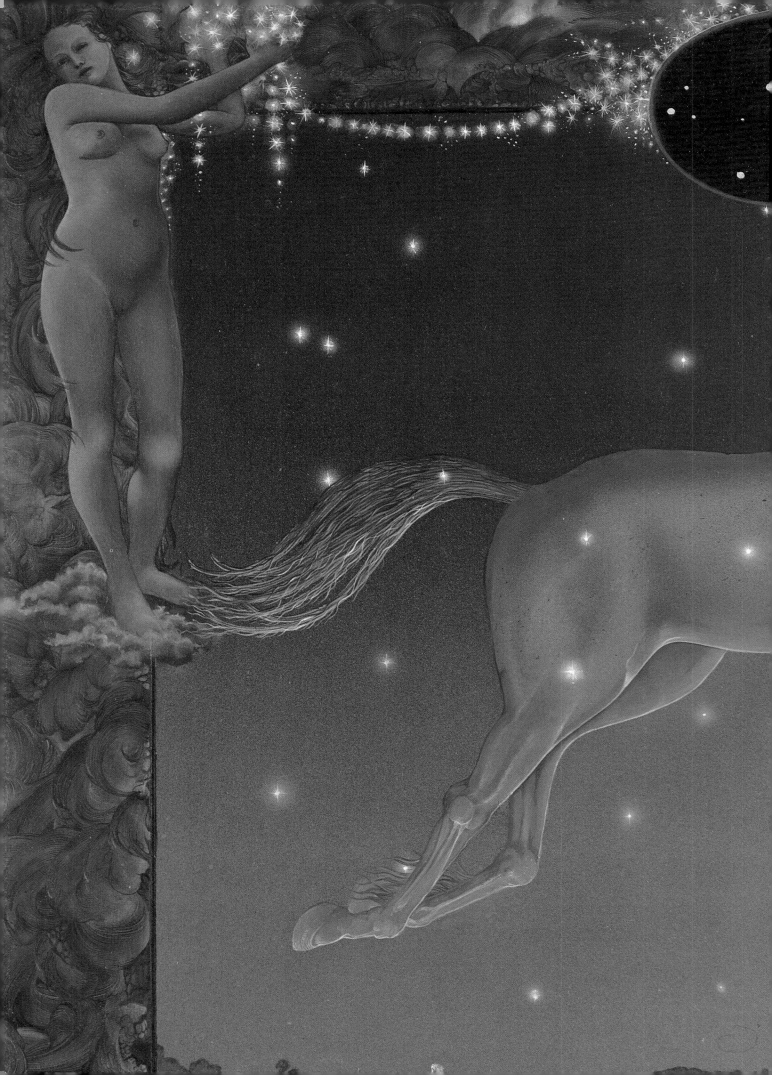